Cool Restaurants Cologne

teNeues

Imprint

Editors: Nicole Rankers, Martin Nicholas Kunz

Photos (location): beer foto (3FRITS, CHEZ CHEF), Anke Schlüter und Lutz Voigtländer (Bento Box). Spiros Soukas (Mongo'S Restaurant, food), Rheinconnection GmbH (Rheinterrassen Köln)
All other photos by Roland Bauer

Introduction: Adrian von Starck

Layout & Pre-press: Thomas Hausberg, Markus Mutz

Imaging: Jan Hausberg

Translations: SAW Communications, Dr. Sabine A. Werner, Mainz
Nina Hausberg (German, English / recipes), Dr. Suzanne Kirkbright (English / introduction), Sabine Boccador (French), Silvia Gómez de Antonio (Spanish), Maria-Letizia Haas (Italian)

Produced by fusion publishing GmbH, Stuttgart . Los Angeles www.fusion-publishing.com

Published by teNeues Publishing Group

teNeues Book Division
Kaistraße 18
40221 Düsseldorf, Germany
Tel.: 0049-(0)211-994597-0
Fax: 0049-(0)211-994597-40
E-mail: books@teneues.de

Press department:
arehn@teneues.de
Tel.: 0049-(0)2152-916-202

www.teneues.com

teNeues Publishing Company
16 West 22nd Street
New York, NY 10010, USA
Tel.: 001-212-627-9090
Fax: 001-212-627-9511

teNeues Publishing UK Ltd.
P.O. Box 402
West Byfleet
KT14 7ZF, Great Britain
Tel.: 0044-1932-403509
Fax: 0044-1932-403514

teNeues France S.A.R.L.
4, rue de Valence
75005 Paris, France
Tel.: 0033-1-55766205
Fax: 0033-1-55766419

teNeues Iberica S.L.
Pso. Juan de la Encina 2–48,
Urb. Club de Campo
28700 S.S.R.R. Madrid, Spain
Tel./Fax: 0034-91-6595876

ISBN-10: 3-8327-9117-5
ISBN-13: 978-3-8327-9117-9

© 2006 teNeues Verlag GmbH + Co. KG, Kempen

Printed in Italy

Bibliographic information published by Die Deutsche Bibliothek.
Die Deutsche Bibliothek lists this publication in the Deutsche Nationalbibliografie; detailed bibliographic data is available in the Internet at http://dnb.ddb.de.

Average price reflects the average cost for a dinner main course without beverages. Recipes serve four.

Contents

Page

Introduction 5

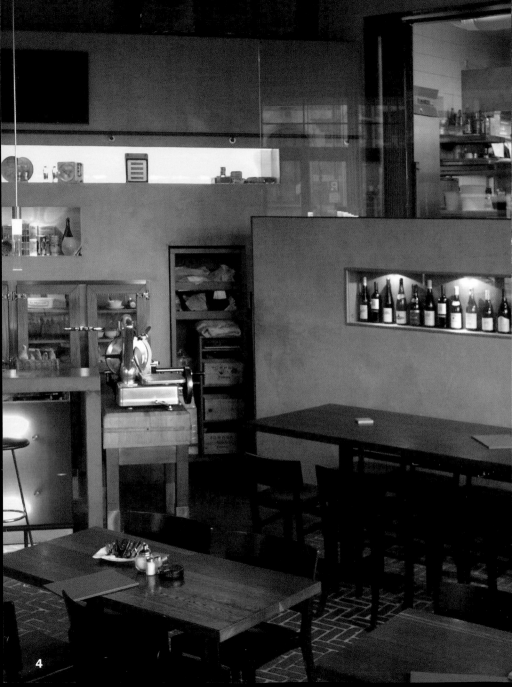

Einleitung

2000 Jahre Stadtgeschichte haben den Kölnern ein reiches Erbe hinterlassen: Den römischen Stadtgrundriss, die romanischen Kirchen, den gotischen Dom, den Karneval und die sprichwörtlich unerschütterliche Lebensfreude. Diese ist verbunden mit dem Bedürfnis der Kölner, sich mit jedem, der die Stadt besucht, auszutauschen und zu feiern. Dazu verabredet man sich zu einem Kölsch – oder auch zu zwei oder dreien – in einer der zahllosen kleinen Kneipen, die in den verschiedenen Innenstadtvierteln fast Tür an Tür liegen, wie in der Südstadt, im Belgischen Viertel oder im Kwartier Latäng (Kölsch für „Quartier Latin"). Als Besucher trifft man fast immer auf eine temperamentvolle und aufgeschlossene Atmosphäre, ein Spiegelbild der Stadtbewohner selbst.

Aber auch in der gehobeneren Gastronomie der Stadt kommt die rheinische Frohnatur zum Ausdruck. Das Spektrum ist groß und oft sind die Grenzen zwischen Bar, Kneipe, Restaurant und Club fließend. Zu finden sind familiäre und nach außen hin unscheinbar wirkende Lokale genauso wie Feinschmeckeradressen, welche die Haute Cuisine mit der für Köln charakteristischen Ungezwungenheit verbinden.

Trotz aller Unterschiede haben viele Lokale gemein, dass man im Gegensatz zur legeren Lebensweise nicht auf überschwängliche Farben und Formen trifft, vielmehr ist ein Hang zur Reduktion spürbar. Besonders in den progressiven Restaurants auf der Ehrenstraße kultiviert man internationalen Zeitgeist in gestalterischer Strenge. Selbst so extravagante Lokale wie das sowjetisch-barocke HoteLux, die Rheinterrassen oder der Dinnerclub setzen bei aller Frische ihrer Formensprache auf ein klares Konzept, was einen wesentlichen Teil ihres Charmes ausmacht.

Cool Restaurants Cologne öffnet die oft gar nicht so einfach zu findenden Türen gefragter Szeneadressen und gibt mit brillanten Fotos Einblick ins Innenleben von 28 Restaurants; eine Insider-Tour durch alle Preisklassen, mit viel Abwechslung in Küche und Design. Eine Einladung zu einer Entdeckungsreise in die Vielfalt des gastronomischen Kölns, auf der man auch kreative Rezepte renommierter Chefköche für die eigene Küche sammeln kann.

Adrian von Starck

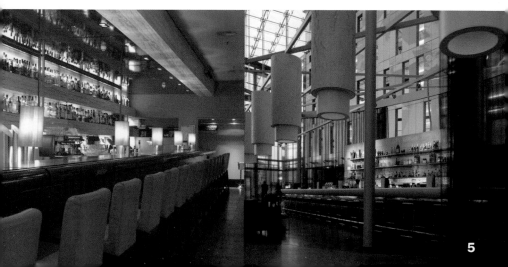

Introduction

2,000 years of the city's history have left Cologne's residents a rich legacy: the city's Roman layout, Romanesque churches, the Gothic cathedral, Carnival and a legendary and unshakeable *joie de vivre*. This cheerfulness is tied up with the need of Cologne's inhabitants to converse and celebrate with every visitor to the city. To help this along, they meet up for a *Kölsch* (a popular local beer)—or even two or three—in one of the numerous small bars, which are almost situated door to door in the different inner-city districts, such as in the Südstadt, the Belgian quarter or the *Kwartier Latäng* (local dialect, or *Kölsch* for the *Quartier Latin*). As a visitor, you almost always encounter a high-spirited and outgoing atmosphere, which is a mirror image of the city's locals.

But the vivacious Rhineland spirit is also expressed in the city's more sophisticated gastronomy. The range is wide and often the distinctions are fluid between bar, pub, restaurant and club. You can find friendly and, on the outside, inconspicuous-looking restaurants, as well as gourmet addresses that combine haute cuisine with informality that is typical of Cologne.

Despite all the differences, many restaurants share the fact that, in contrast to the casual lifestyle, they do not focus on exuberant colors and forms, but rather have a tangible preference for reduction. Especially in the progressive restaurants on the Ehrenstraße, they cultivate the international *Zeitgeist* in design rigor. Even such extravagant restaurants as the Soviet-baroque HoteLux, the Rheinterrassen or the Dinnerclub concentrate on a clear concept, despite all the freshness of their form language, and this makes the essential contribution to their charm.

Cool Restaurants Cologne opens doors—often not so easy to find—of the popular, trendy addresses and, with brilliant photos, gives an insight into the inner life of 28 restaurants: an insider's tour of all the price categories, with lots of variation in cuisine and design. This invitation also takes you on a voyage of discovery into the diversity of Cologne's gastronomy, as well as helping you to collect creative recipes by famous chefs for your own cuisine.

Adrian von Starck

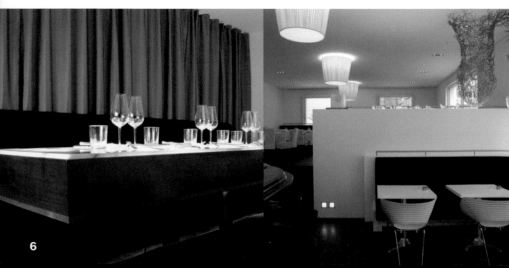

Introduction

2 000 ans d'histoire ont laissé aux habitants de Cologne un riche héritage qui comprend notamment le plan romain de la ville, les églises romanes, la cathédrale gothique, le carnaval et une inlassable joie de vivre. Celle-ci est liée aux besoins des habitants d'échanger et de festoyer avec tous ceux qui visitent la ville. On se retrouve donc autour d'une bière (ou de plusieurs), la fameuse *Kölsch*, dans l'un des innombrables petits bistrots qui peuplent les différents quartiers, notamment le Südstadt, le Quartier Belge et le *Kwartier Latäng* qui signifie *quartier latin* en dialecte. Ceux qui arrivent à Cologne découvrent presque toujours une atmosphère chaleureuse, reflet même de ses habitants.

Cette nature heureuse propre à la région rhénane s'exprime également dans la haute gastronomie de la ville. Le choix est vaste et les limites sont souvent floues entre les bars, les troquets, les restaurants et les clubs. On peut trouver aussi bien des lieux familiers et discrets dans leur présentation extérieure que des adresses raffinées qui associent la haute cuisine à la tendance décontractée et naturelle de Cologne.

En dépit de leur diversité, ces nombreux endroits ont en commun, contrairement à un mode de vie léger, des couleurs et un design sans excès, qui tendent plutôt vers plus de sobriété. Dans les restaurants progressifs de la Ehrenstraße, on cultive un esprit international aux formes rigoureuses. Même les lieux extravagants, tels que l'HoteLux soviétique-baroque, le Rheinterrassen et le Dinnerclub ont toujours recours à un concept simple en dépit de leur design très actuel ; ce qui fait d'ailleurs une grande partie de leur charme.

Cool Restaurants Cologne ouvre les portes de certains lieux très tendances et pas si évidents à trouver et offre un aperçu de l'intérieur de 28 restaurants, illustré par de très belles photographies. Un choix proposant toutes les classes de prix, avec beaucoup d'inventivité dans la cuisine et le design. Une invitation au voyage dans la diversité gastronomique de Cologne permettant de collectionner aussi les recettes créatives de chefs cuisiniers renommés.

Adrian von Starck

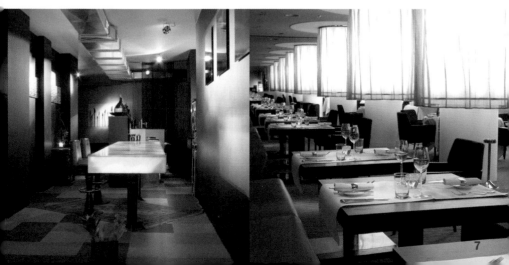

Introducción

Los 2.000 años de historia de la ciudad han dejado a los coloneses una rica herencia: el plano de la ciudad romano, las iglesias románicas, la catedral gótica, el carnaval y una inquebrantable alegría de vivir. Esta característica se une a la necesidad de los coloneses de conversar y pasárselo bien con todos los que llegan para visitar la ciudad. Se queda para tomar una cerveza *Kölsch*, o dos o tres, en una de las innumerables y pequeñas tascas que se amontonan, casi puerta con puerta, en los diferentes barrios de la ciudad, como en la Südstadt, en el barrio belga o en el *Kwartier Latäng* (dialecto *Kölsch* para *Quartier Latin* o barrio latino). En ellos, los visitantes encuentran casi siempre una atmósfera abierta y alegre, un reflejo de la forma de ser de sus habitantes. Esta naturaleza abierta típica de Renania también se refleja en la alta gastronomía de la ciudad. El abanico es grande y a menudo los límites entre bar, tasca, restaurante y club se difuminan. La oferta incluye locales familiares de aspecto poco llamativo desde el exterior, hasta lugares para sibaritas en los que la *haute cuisine* se fusiona con la naturalidad característica de Colonia. A pesar de las diferencias existentes entre estos locales todos tienen en común una decoración que, en vez de reflejar con colores y formas exuberantes la forma de vida desenvuelta de la ciudad, muestra más bien una clara tendencia a la reducción. En los modernos restaurantes de la Ehrenstraße es donde se cultiva de manera especial el espíritu internacional actual con una creativa sobriedad. Incluso extravagantes locales como el HoteLux, de estilo ruso barroco, el Rheinterrassen o el Dinnerclub reflejan, a pesar de la frescura de su lenguaje formal, un concepto de sencillez que es parte esencial de su encanto.

Cool Restaurants Cologne le abre las puertas a veces difíciles de encontrar de 28 de los restaurantes más de moda de la ciudad con fotos brillantes de su vida interior; un recorrido por todas las clases de precios y con una gran variedad en la cocina y en el diseño. Una invitación a realizar un viaje por la diversidad gastronómica de Colonia en el que las creativas recetas de los grandes cocineros pueden servirnos de inspiración para nuestra propia cocina.

Adrian von Starck

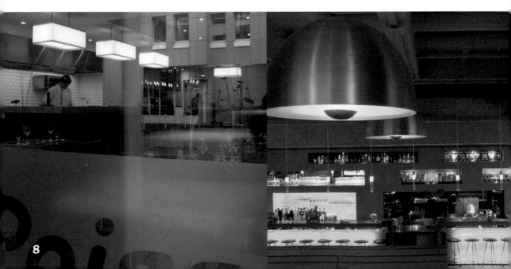

Introduzione

2000 anni di storia hanno lasciato agli abitanti di Colonia una ricca eredità: le fondamenta romane, le chiese romaniche, il Duomo gotico, il carnevale e la proverbiale, imperturbabile allegria, legata all'esigenza di comunicare e festeggiare con chiunque visiti la loro città. Per questo ci si dà appuntamento per una – o anche due, o tre – *Kölsch*, la birra tipica di Colonia, in una delle innumerevoli, piccole birrerie situate quasi porta a porta nei vari quartieri cittadini, come nella Südstadt, nel Quartiere belga o nel *Kwartier Latäng* (che in dialetto locale significa *Quartiere Latino*). Il turista vi trova di solito un'atmosfera vivace ed aperta che rispecchia il carattere degli abitanti.

Ma la gaiezza tipica di chi vive sulle rive del Reno si esprime anche nella gastronomia d'alto livello, il cui ampio spettro spesso non permette di individuare i confini che intercorrono tra bar, birreria, ristorante e club: si possono trovare sia locali di tipo familiare dall'aspetto poco appariscente, sia ritrovi per buongustai, che uniscono la Haute Cuisine alla naturalezza tipica di questa città.

Malgrado tutte le differenze, molti locali hanno in comune una caratteristica: nonostante lo stile di vita semplice e senza pretese, colori e forme non sono mai eccessivi, ma chi osserva riscontra – piuttosto – una tendenza al minimalismo. Specialmente nei ristoranti di stampo progressivo della Ehrenstraße si coltiva, in un insieme di linee austere, lo spirito del tempo in clima internazionale. Perfino locali stravaganti come l'HoteLux, di stile barocco sovietico, le Rheinterrassen o il Dinnerclub, nonostante la freschezza del linguaggio formale, puntano su di un concetto ben definito, parte essenziale del loro fascino.

Cool Restaurants Cologne apre le porte – spesso non facili da trovare – degli indirizzi che dominano la scena offrendo, grazie alle vivaci fotografie, uno scorcio negli interni di 28 ristoranti: una carrellata – suggerita dagli insider – che percorre tutte le classi di prezzo, in una straordinaria varietà di cucina e di design. È un invito alla scoperta dei mille aspetti della Colonia gastronomica, un viaggio durante il quale è pure possibile raccogliere per la propria cucina ricette creative di cuochi rinomati.

Adrian von Starck

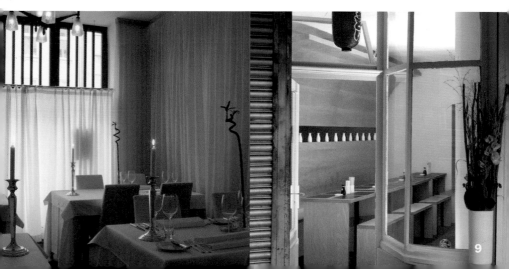

3FRITS

Design: Dorothee Spitz | Owner: 3Frits GmbH

Ehrenstraße 43c | 50672 Köln | Stadtmitte
Phone: +49 221 2 58 95 12
www.3frits.de
Subway: Rudolfplatz
Opening hours: Mon–Sat noon to 10 pm, Sun closed
Average price: € 5
Cuisine: Luxury frites

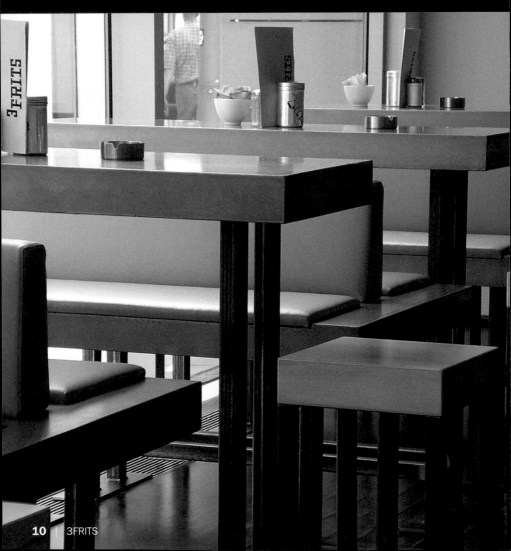

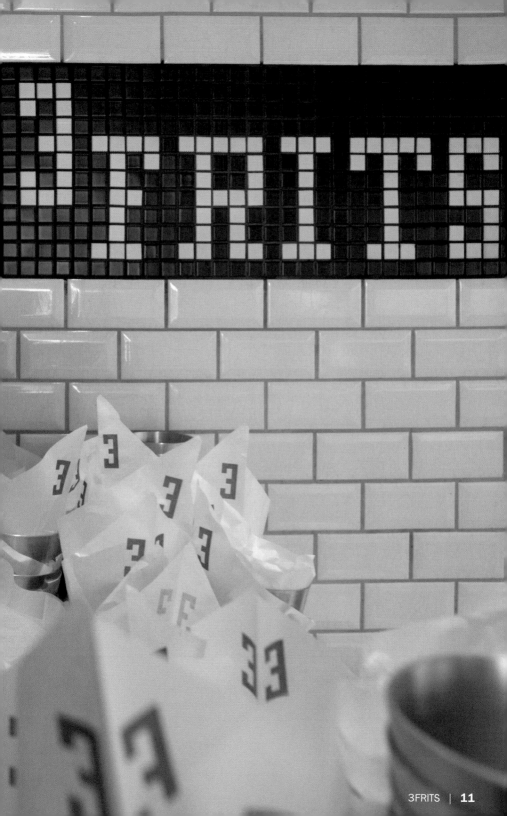

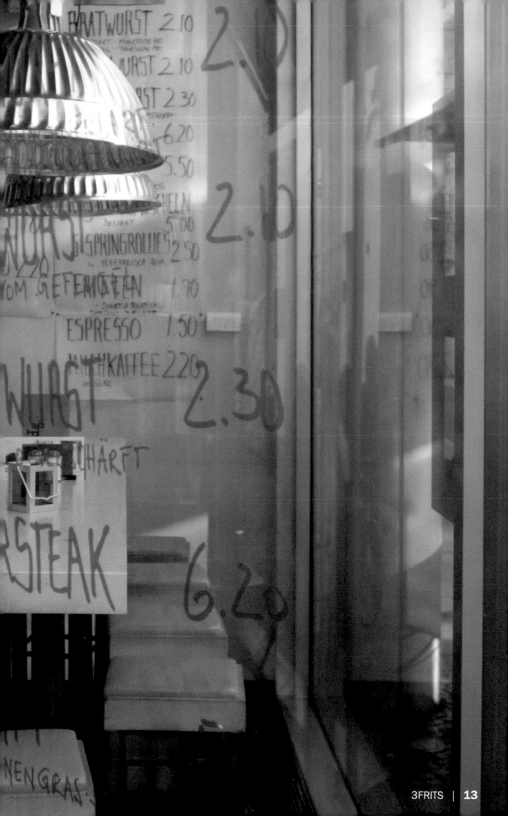

Scampispieße auf Zitronengras

Scampi Spits on Lemon Grass
Brochettes de scampis à la citronnelle
Brochetas de langostinos sobre limoncillo
Spiedini di scampi con cedronella

16 Scampis
4 Stangen Zitronengras
Salz, Pfeffer
3 EL Rapsöl
2 EL Zitronensaft
4 Zitronenscheiben zur Dekoration

Jeweils 4 Scampis auf 1 Stange Zitronengras aufspießen und mit Salz und Pfeffer würzen. Das Öl in einer Pfanne erhitzen und die Scampispieße von beiden Seiten ca. 2 Minuten anbraten. Mit Zitronensaft beträufeln und mit den Zitronenscheiben auf vier Tellern anrichten.

16 scampi
4 spears of lemon grass
Salt, pepper
3 tbsp rapeseed oil
2 tbsp lemon juice
4 lemon slices, for decoration

Place 4 scampi each onto 1 spear of lemon grass and season with salt and pepper. Heat the oil in a saucepan and sautée the scampi spits on both sides for approx. 2 minutes. Drizzle with lemon juice and arrange on four plates with the lemon slices.

16 scampis
4 branches de citronnelle
Sel, poivre
3 c. à soupe d'huile de colza
2 c. à soupe de jus de citron
4 rondelles de citron pour la garniture

Piquer 4 scampis sur chaque branche de citronnelle, saler et poivrer. Chauffer l'huile dans une poêle et saisir les brochettes de scampi de chaque côté pendant 2 minutes environ. Arroser de quelques gouttes de jus de citron, servir sur quatre assiettes et garnir de rondelles de citron.

16 langostinos
4 ramas de limoncillo
Sal, pimienta
3 cucharadas de aceite de colza
2 cucharadas de zumo de limón
4 rodajas de limón para decorar

Inserte 4 langostinos en cada una de las ramas de limoncillo y salpimiente. Caliente el aceite en una sartén y fría las brochetas de langostinos durante aprox. 2 minutos por cada lado. Vierta por encima el zumo de limón y coloque las brochetas en 4 platos adornando con las rodajas de limón.

16 scampi
4 bastoncini di cedronella
Sale, pepe
3 cucchiai di olio di colza
2 cucchiai di succo di limone
Per la guarnizione: 4 fettine di limone

Infilzare 4 scampi su ogni bastoncino di cedronella, salare e pepare. Riscaldare l'olio in una padella e rosolarvi gli spiedini da entrambi i lati per circa 2 minuti. Pillottare con succo di limone e servirli su quattro piatti guarnendoli con fettine di limone.

Amando Restaurant

Design: art und weise, Stefan Weinberger, Gabi Heiderscheidt
Chef: Patu Habacht | Owner: Anna M. Höttecke

Klarastraße 2–4 | 50823 Köln | Ehrenfeld
Phone: +49 221 5 62 60 65
www.amando-koeln.de
Subway: Körnerstraße, Venloer Straße
Opening hours: Tue–Sat 7 pm to 1 am, Mon and Sun closed
Average price: € 23
Cuisine: French

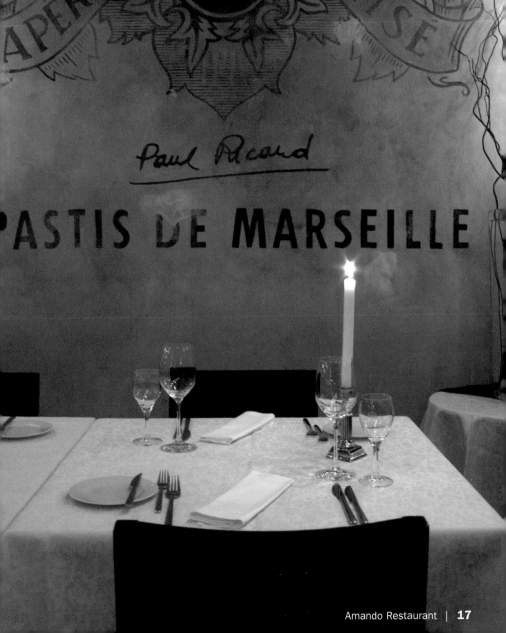

Störfilet
mit Kaviar und Stampfkartoffeln

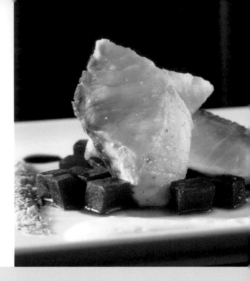

Sturgeon Fillet with Caviar and
Mashed Potatoes

Filet d'esturgeon au caviar et aux pommes
de terre écrasées

Filete de esturión con caviar y puré de
patata

Filetto di storione con caviale e patate
schiacciate

4 Stück Störfilet
Salz, Pfeffer
5 EL Butter
350 g Rote-Bete-Würfel
150 g Rote Bete, grob gewürfelt
1 Schalotte, gewürfelt
1 Knoblauchzehe, gehackt
300 ml Fischfond
1 TL Agar-Agar
5 große, mehlige Kartoffeln, mit Schale gekocht
3 EL saure Sahne
4 TL Kaviar
Algen zur Dekoration
Thaispargel

Die Rote-Bete-Würfel zusammen mit der Schalotte
und dem Knoblauch in einer Pfanne anbraten und
mit Fischfond ablöschen. Würzen.
Die 150 g Rote Bete mit 2 EL Wasser aufkochen,
pürieren und mit dem Agar-Agar mischen. In eine
flache Form geben und kaltstellen. Nach 1 Stunde
kleine Kreise ausstechen.
Die Kartoffeln schälen, grob zerstampfen und mit
saurer Sahne und 2 EL Butter mischen. Mit Salz
und Pfeffer würzen.
Das Störfilet würzen und in 3 EL Butter von beiden Seiten 2 Minuten anbraten.
Zum Servieren das Störfilet auf den marinierten Rote-Bete-Würfeln anrichten, Kaviar auf die
Stampfkartoffeln geben und mit dem Gelee, den
Algen und dem Thaispargel garnieren.

4 pieces of sturgeon fillet
Salt, pepper
5 tbsp butter
12 oz beetroot cubes
5 oz beetroot, roughly diced
1 shallot, diced
1 garlic clove, chopped
300 ml fish stock
1 tsp agar-agar
5 large, soft-boiling potatoes, boiled in skins
3 tbsp sour cream
4 tsp caviar
Algae for decoration
Thai asparagus

Sautée the beetroot cubes in a saucepan together with the shallot and garlic and drench with the
fish stock. Season.
Bring 5 oz beetroot to the boil in 2 tbsp water,
purée, and mix with the agar-agar. Place on a flat
tray and chill in the refrigerator. After 1 hour, cut
out small circles.
Peel, roughly mash the potatoes and mix them
with sour cream and 2 tbsp butter. Season with
salt and pepper.
Season the sturgeon fillet and sautée for 2 minutes on both sides in 3 tbsp butter.
To serve, arrange the sturgeon fillet on the
marinated, diced beetroot, arrange caviar on the
mashed potatoes and garnish with the gelée, the
algae and Thai asparagus.

4 filets d'esturgeon
Sel, poivre
5 c. à soupe de beurre
350 g de dés de betterave rouge
150 g de betterave rouge coupée grossièrement
en dés
1 échalote coupée en dés
1 gousse d'ail hachée
300 ml de fond de poisson
1 c. à café d'agar-agar
5 grosses pommes de terre farineuses cuites
avec la peau
3 c. à soupe de crème fraîche
4 c. à café de caviar
Algues pour la garniture
Asperges thaï

Dans une poêle, faire revenir les dés de betterave avec l'échalote et l'ail, et mouiller avec le fond de poisson. Aromatiser.
Porter à ébullition les 150 g de betterave rouge dans 2 c. à soupe d'eau, puis réduire en purée et ajouter l'agar-agar. Verser dans un moule plat et laisser au frais. Démouler 1 heure après en formant des petits cercles.
Éplucher les pommes de terre et les écraser grossièrement. Ajouter la crème fraîche et 2 c. à soupe de beurre. Saler et poivrer.
Aromatiser le filet d'esturgeon et le saisir dans 2 c. à soupe de beurre 2 minutes de chaque côté.
Servir le filet d'esturgeon sur les dés de betterave rouge marinés, ajouter le caviar sur la purée de pommes de terre et garnir avec la gelée, les algues et les asperges thaï.

4 trozos de filete de esturión
Sal, pimienta
5 cucharadas de mantequilla
350 g de remolacha, en dados
150 g de remolacha, en trozos
1 chalote, en dados
1 diente de ajo, picado
300 ml de fondo de pescado
1 cucharadita de agar-agar
5 patatas grandes harinosas, cocidas con piel
3 cucharadas de nata agria
4 cucharaditas de caviar
Algas para decorar
Espárragos *thai*

Saltee en una sartén los dados de remolacha junto con el chalote y el ajo e incorpore el fondo de pescado. Sazone.
Hierva los 150 g de remolacha en 2 cucharadas de agua, hágala puré y mézclela con el agar-agar. Ponga la mezcla en un molde plano y guárdela en el frigorífico. Después de 1 hora recorte pequeños círculos.
Pele las patatas, macháquelas un poco y mézclelas con la nata agria y 2 cucharadas de mantequilla. Salpimiente.
Sazone el filete de esturión y fríalo en 3 cucharadas de mantequilla durante 2 minutos por cada lado.
Para servir el esturión coloque los trozos sobre los dados marinados de remolacha, ponga caviar sobre el puré de patatas y adorne con la gelatina, las algas y con espárragos *thai*.

4 filetti di storione
Sale, pepe
5 cucchiai di burro
350 g di barbabietole rosse a dadini
150 g di barbabietole rosse tagliate grossolanamente
1 scalogno tagliato a dadini
1 spicchio d'aglio tritato
300 ml di brodo di pesce
1 cucchiaio di agar-agar
5 patate grosse e farinose cotte con la buccia
3 cucchiai di panna acida
4 cucchiaini di caviale
Per la guarnizione: alghe
Asparagi tailandesi

Rosolare in una padella i dadini di barbabietola con lo scalogno e l'aglio, bagnare con il brodo di pesce e condire.
Portare a cottura con 2 cucchiai d'acqua le barbabietole tagliate a pezzi, passarle con il passaverdura ed unirvi l'agar-agar. Versare il composto in uno stampo piatto e metterlo in frigo. Dopo 1 ora, ricavarne dei piccoli dischi.
Sbucciare le patate, schiacciarle grossolanamente ed incorporarvi la panna acida e 2 cucchiai di burro. Salare e pepare.
Condire i filetti di storione e rosolarli in 3 cucchiai di burro da entrambi i lati per 2 minuti.
Disporre i filetti sui dadini di barbabietola marinati, cospargere il caviale sulla purea di patate e guarnire con la gelatina, le alghe e gli asparagi tailandesi.

APROPOS CÖLN
Restaurant Hornsleth

Design: Kristian von Hornsleth | Chef: Werner Mertz
Owners: Klaus Ritzenhöfer, Daniel Riedo

Mittelstraße 12 | 50672 Köln | Altstadt Nord
Phone: +49 221 27 25 19 20
www.apropos-coeln.de | restaurant@apropos-coeln.de
Subway: Neumarkt
Opening hours: Mon 10 am to 8 pm, Tue–Sat 10 am to 11:30 pm, Sun closed
Average price: € 18
Cuisine: Crossover
Special features: Business lunch and changing events

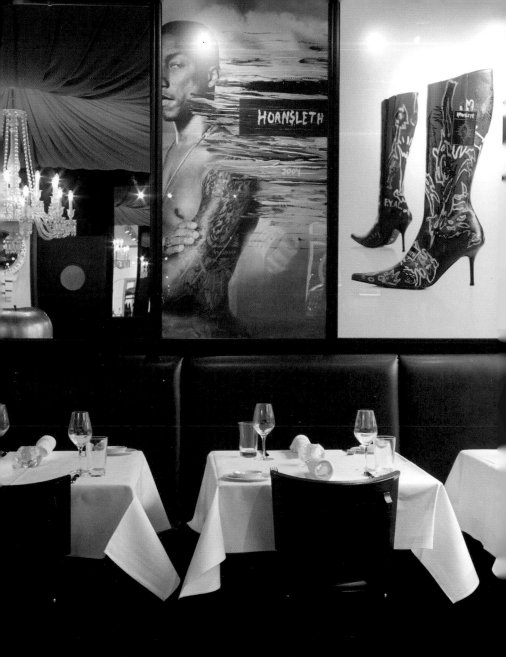

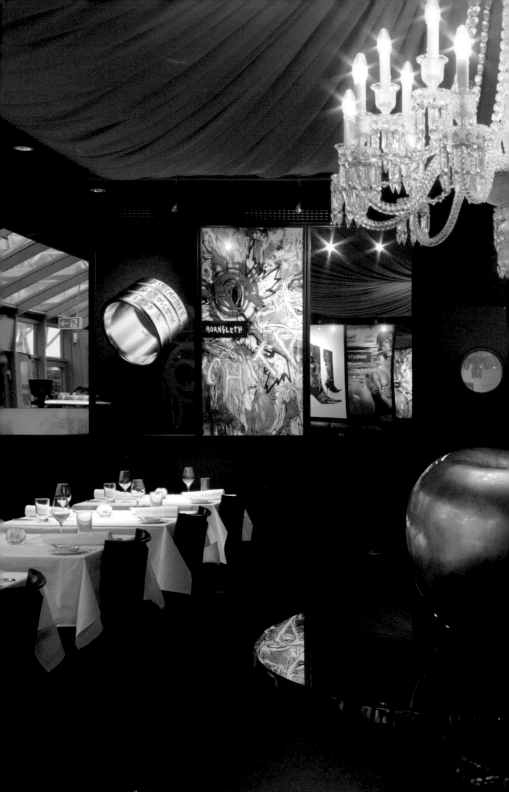

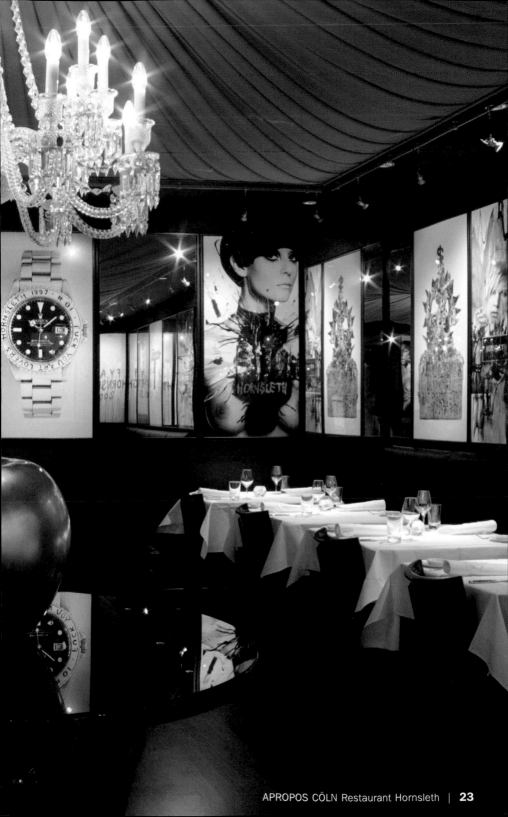

Riesengarnelen-spieße mit Zitronengras-nudeln und Kokos-Chili-Schaum

King Prawn Spits with Lemon Grass Noodles and Coconut-Chili-Foam

Brochettes de crevettes géantes aux nouilles à la citronnelle et à la mousse de coco pimentée

Brochetas de langostinos con fideos de limoncillo y espuma de coco y guindilla

Spiedini di gamberoni con pasta alla cedronella e spuma al cocco e peperoncino

180 g Mehl
2 Eier
4 TL Zitronengraspulver
2 EL Olivenöl
1 Prise Salz

Das Zitronengraspulver mit Öl mischen und aus allen Zutaten einen geschmeidigen Teig kneten. Mindestens 4–5 Stunden kalt stellen. Den Teig 2 mm dünn ausrollen und in breite Nudeln schneiden. In kochendem Salzwasser ca. 2 Minuten blanchieren.

16 Riesengarnelen, ohne Kopf, mit Schale
4 Stangen Zitronengras, halbiert
4 EL Sesamöl
2 EL Noilly Prat
800 ml Sahne
400 ml Kokosmilch

1 TL rote Chili, gehackt
4 EL Butter
Salz, Pfeffer, Zucker, Limettensaft
Asiatische Kresse zur Dekoration

Die Riesengarnelen putzen, den Darm entfernen, die Schale waschen und beiseite stellen. Je 2 Garnelen auf einen halbierten Spieß stecken und mit 2 EL Sesamöl bestreichen. Die Garnelenschalen in 2 EL Sesamöl anschwitzen, mit Noilly Prat ablöschen und mit Sahne und Kokosmilch auffüllen. Rote Chili hinzufügen und abschmecken. 20 Minuten einkochen lassen. Die Garnelenspieße würzen, in einer Pfanne von beiden Seiten 2 Minuten scharf anbraten und warm stellen. Die Nudeln in 2 EL Butter schwenken, die Sauce abseihen, mit dem Mixer aufschäumen, restliche Butter zugeben und mit Salz, Pfeffer, Zucker und Limettensaft abschmecken.

6 oz flour
2 eggs
4 tbsp lemon grass powder
2 tbsp olive oil
1 pinch salt

Mix the lemon grass powder with the oil and kneed all the ingredients to a smooth dough. Store in the refrigerator for at least 4–5 hours. Roll the dough out to a thickness of 2 mm and cut into thick noodles. Blanch in boiling, salted water for about 2 minutes.

16 king prawns, headless, with shell
4 spears lemon grass, halved
4 tbsp sesame oil
2 tbsp Noilly Prat (Vermouth)
800 ml cream
400 ml coconut milk

1 tsp red chili, chopped
4 tbsp butter
Salt, pepper, sugar, lime juice
Asian cress for decoration

Clean the king prawns, remove the intestine, wash the shell and set aside. Place 2 prawns each on a halved lemon grass spear and coat with 2 tbsp of sesame oil. Sautée the prawn shells in 2 tbsp sesame oil, drench with Noilly Prat and fill with cream and coconut milk. Add the red chili and season to taste. Allow to simmer for 20 minutes. Season the prawn spits, sear in a pan on both sides for 2 minutes and keep warm. Toss the noodles in 2 tbsp butter, foam the pre-sieved sauce in the blender, add the remaining butter and season to taste with salt, pepper, sugar and lime juice.

180 g de farine
2 œufs
4 c. à café de poudre de citronnelle
2 c. à soupe d'huile d'olive
1 pincée de sel

Mélanger la poudre de citronnelle et l'huile, et préparer une pâte malléable avec tous les ingrédients. Conserver au frais pendant au moins 4–5 heures. Ensuite, étaler la pâte en gardant 2 mm d'épaisseur et la découper en nouilles larges. Blanchir les nouilles dans l'eau bouillante pendant 2 minutes environ.

16 crevettes géantes sans tête, non épluchées
4 branches de citronnelle coupées en deux
4 c. à soupe d'huile de sésame
2 c. à soupe de vermouth Noilly Prat
800 ml de crème liquide
400 ml de lait de coco

1 c. à café de piment rouge haché
4 c. à soupe de beurre
Sel, poivre, sucre, jus de citron vert
Cresson asiatique en guise de garniture

Nettoyer et vider les crevettes, laver la peau et la réserver. Piquer 2 crevettes sur chaque demi-brochette et les badigeonner de 2 c. à soupe d'huile de sésame. Faire suer la peau des crevettes dans 2 c. à soupe d'huile de sésame, mouiller de vermouth et verser la crème liquide et le lait de coco. Ajouter le piment et aromatiser. Laisser réduire pendant 20 minutes. Aromatiser les brochettes de crevettes et bien les poêler 2 minutes de chaque côté. Puis les garder au chaud. Saisir légèrement les nouilles dans 2 c. à soupe de beurre. Filtrer la sauce avant de la faire mousser au mixer. Ajouter le reste de beurre, saler, poivrer, sucrer et verser le jus de citron vert.

180 g de harina
2 huevos
4 cucharaditas de limoncillo molido
2 cucharadas de aceite de oliva
1 pizca de sal

Mezcle el limoncillo en polvo con el aceite y haga una masa suave con todos los ingredientes. Déjela enfriar durante un mínimo de 4–5 horas. Extienda la masa hasta un espesor de 2 mm y córtela en fideos gruesos. Escáldelos en agua hirviendo durante aprox. 2 minutos.

16 langostinos, sin cabeza, con piel
4 ramas de limoncillo, en mitades
4 cucharadas de aceite de oliva
2 cucharadas de Noilly Prat
800 ml de nata
400 ml de leche de coco

1 cucharadita de guindilla roja, picada
4 cucharadas de mantequilla
Sal, pimienta, azúcar, zumo de lima
Berros asiáticos para decorar

Limpie los langostinos, retire el hilo intestinal, lave las pieles y reserve. Inserte 2 langostinos en cada mitad de rama y úntelos con 2 cucharadas de aceite de sésamo. Rehogue las pieles en 2 cucharadas de aceite de sésamo, vierta dentro del Noilly Prat y añada la nata y la leche de coco. Incorpore la guindilla y sazone. Deje que hierva durante 20 minutos. Sazone las brochetas, fríalas a fuego fuerte en una sartén por ambos lados durante 2 minutos y resérvelas calientes. Saltee los fideos en 2 cucharadas de mantequilla, cuele la salsa y bátala hasta que tenga espuma, añada el resto de la mantequilla y sazone con sal, pimienta, azúcar y zumo de lima.

180 g di farina
2 uova
4 cucchiaini di polvere di cedronella
2 cucchiai di olio d'oliva
1 presa di sale

Mescolare la polvere di cedronella con l'olio e formare con tutti gli ingredienti una pasta maneggevole. Mettere in frigo per almeno 4–5 ore. Stendere una sfoglia dello spessore di 2 mm e ricavarne delle strisce larghe. Scottare le strisce in acqua salata bollente per circa 2 minuti.

16 gamberoni senza testa con il guscio
4 bastoncini di cedronella tagliati a metà
4 cucchiai di olio di sesamo
2 cucchiai di Noilly Prat
800 ml di panna
400 ml di latte di cocco

1 cucchiaino di peperoncino rosso tritato
4 cucchiai di burro
Sale, pepe, zucchero, succo di limetta
Per la guarnizione: crescione asiatico

Pulire i gamberoni, svuotarli, lavare il guscio e tenerli da parte. Infilzare 2 gamberoni su ogni spiedino tagliato a metà e pillottare con 2 cucchiai di olio di sesamo. Rosolare i gusci dei gamberoni in 2 cucchiai di olio di sesamo, bagnare con Noilly Prat e ricoprire con la panna ed il latte di cocco. Unire il peperoncino rosso, assaggiare e regolare il condimento. Far restringere per 20 minuti. Condire gli spiedini di gamberoni, rosolarli in padella a fuoco vivo da entrambi i lati per 2 minuti e tenerli in caldo. Saltare la pasta in 2 cucchiai di burro, passare la salsa al setaccio, montarla a schiuma con il frullatore, unire il restante burro, assaggiare e condire con sale, pepe, zucchero e succo di limetta.

Bento Box

Design: Philip Grube | Chef: Keita Wojciechowski
Owner: Bento Box GmbH

Ubierring 33 | 50678 Köln | Südstadt
Phone: +49 221 8 01 69 96
www.bentobox.de
Subway: Chlodwigplatz, Ubierring
Opening hours: Mon–Thu noon to 3 pm, 6 pm to 10 pm, Fri noon to 3 pm, 6 pm to 10:30 pm, Sat 6 pm to 10:30 pm, Sun 6 pm to 10 pm
Average price: € 8.50
Cuisine: Japanese

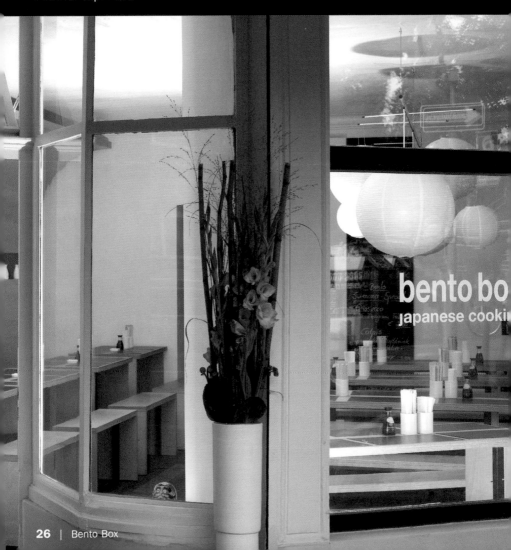

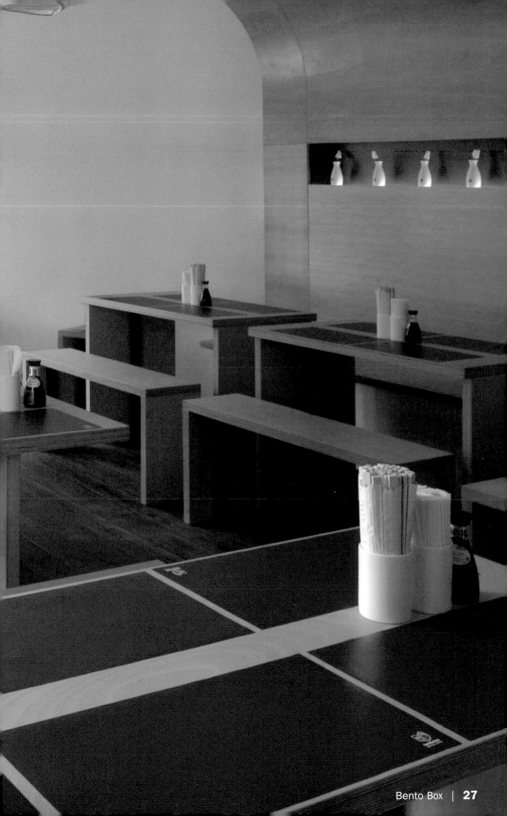

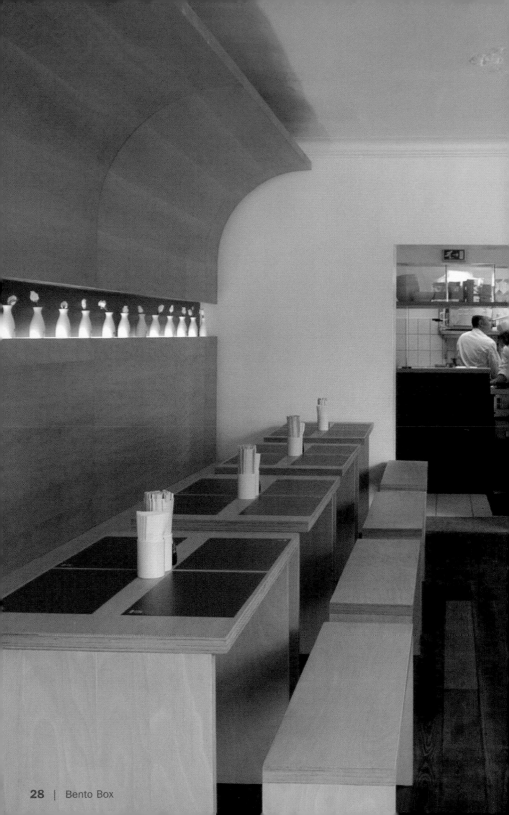

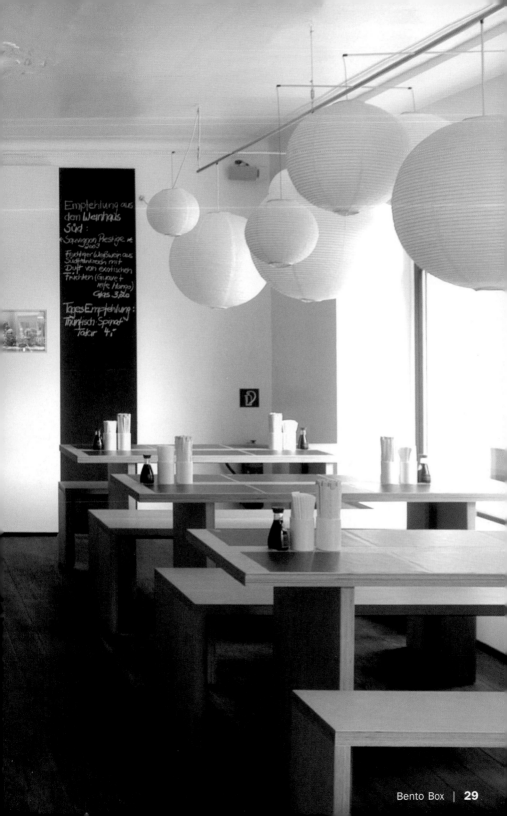

Capricorn [i] Aries
Brasserie

Design: Judith Werner | Chef: Martin Kräber | Owner: Judith Werner

Alteburgerstraße 31 | 50678 Köln | Südstadt
Phone: +49 221 3 97 57 10
Subway: Chlodwigplatz
Opening hours: Mon–Fri noon to 3 pm, 6 pm to 1 am, Sat 6 pm to 1 am, Sun closed
Average price: € 17
Cuisine: French Bistro
Special features: Cook courses, Sacre Bleu music program with light show

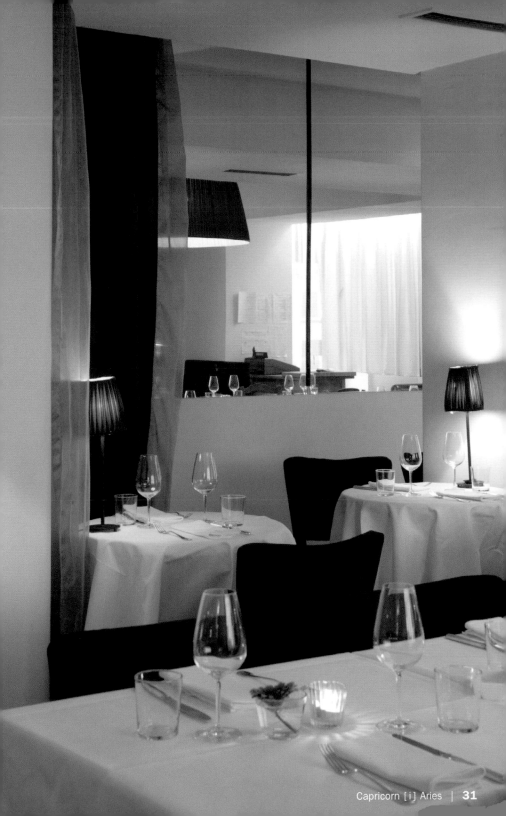

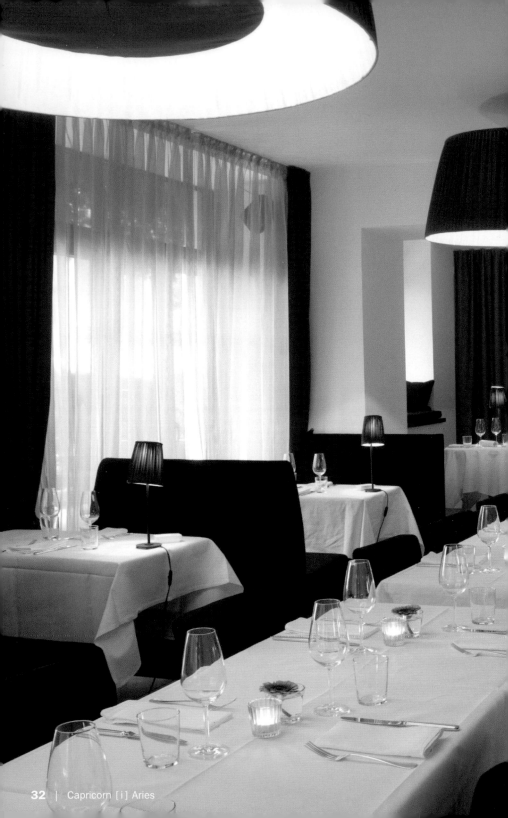

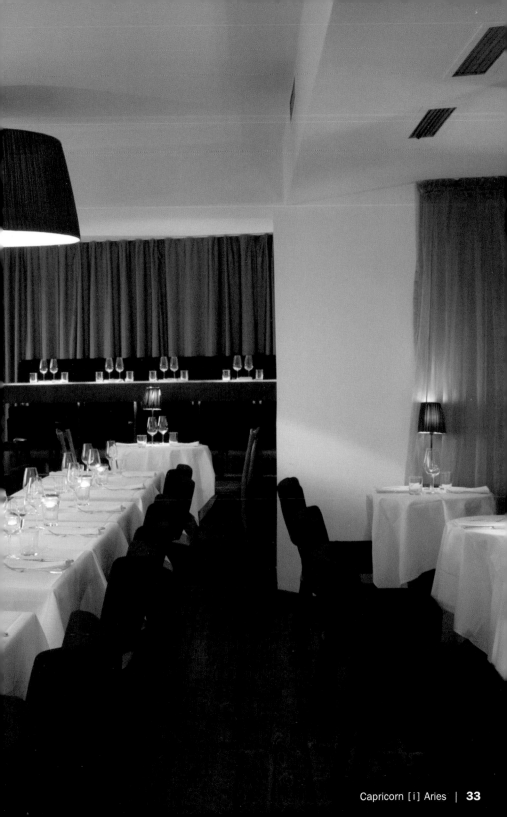

Hausgemachter
Wildschwein-schinken

Homemade Wild Boar Ham

Jambon de sanglier fait maison

Jamón de jabalí casero

Prosciutto di cinghiale fatto in casa

1 Wildschweinkeule
Pro kg Fleisch:
3 TL Pökelsalz
1 TL Meersalz
1 TL Zucker
Je 1 Zweig Thymian, Rosmarin, Petersilie
½ TL Pfefferkörner
½ TL Senfkörner
½ TL Wacholderkörner
1 Lorbeerblatt
Alle Gewürze fein zerstoßen, mit den Kräutern mischen und die Keule damit einreiben. 3–4 Wochen im Kühlschrank marinieren lassen.

120 g Keniabohnen (feine grüne Bohnen)
120 g Pfifferlinge, geputzt
1 Schalotte, gewürfelt
Salz, Pfeffer

3 EL Weißweinessig
2 EL Kürbiskernöl
Die Bohnen blanchieren, die Pilze anbraten und alle Zutaten in einer Schüssel mischen. Abschmecken und ca. 10 Minuten ziehen lassen.

200 g Crème fraîche
Je 1 kleiner Bund Petersilie, Schnittlauch, Majoran, Thymian, gehackt
Salz, Pfeffer, Zitronensaft
Alle Zutaten mischen, abschmecken und kaltstellen.

Zum Servieren den Salat in die Mitte des Tellers geben, den Schinken dünn aufschneiden und mit der Kräuter-Crème-fraîche garnieren.

1 leg of wild boar
Per 2 ¼ lb meat:
3 tsp pickling salt
1 tsp sea salt
1 tsp sugar
One sprig each of thyme, rosemary and parsley
½ tsp peppercorns
½ tsp mustard seeds
½ tsp juniper seeds
1 bay leaf
Finely crush all the spices, mix with the herbs and rub into the ham joint. Allow to marinate for 3–4 weeks in the refrigerator.

4 oz Kenya beans (fine green beans)
4 oz chanterelles, cleaned
1 shallot, diced
Salt, pepper

3 tbsp white wine vinegar
2 tbsp pumpkin seed oil
Blanch the beans, sautée the mushrooms and mix all the ingredients in a bowl. Season to taste and allow to simmer for approx. 10 minutes.

7 oz crème fraîche
1 bunch each of parsley, chives, marjoram, thyme, chopped
Salt, pepper, lemon juice
Mix all the ingredients, season to taste and chill in the refrigerator.

To serve, place the salad in the middle of the dish, carve the ham into thin slices and garnish with the herb crème fraîche.

1 cuissot de sanglier
Par kg de viande:
3 c. à café de sel nitrité
1 c. à café de sel de mer
1 c. à café de sucre
1 branche de thym, 1 de romarin et 1 de persil
½ c. à café de poivre en grains
½ c. à café de grains de moutarde
½ c. à café de baies de genièvre
1 feuille de laurier
Bien broyer toutes les épices, les mélanger aux herbes et frotter le cuissot avec cette préparation. Laisser mariner 3–4 semaines au réfrigérateur.

120 g de haricots du Kenya (haricots verts fins)
120 g de girolles nettoyées
1 échalote coupée en dés
Sel, poivre

3 c. à soupe de vinaigre blanc
2 c. à soupe d'huile de pépin de courge
Blanchir les haricots, poêler les champignons et mélanger tous les ingrédients dans un plat creux. Assaisonner et laisser macérer 10 minutes environ.

200 g de crème fraîche
1 petit bouquet de persil, 1 de ciboulette, 1 d'origan et 1 de thym haché
Sel, poivre, jus de citron
Mélanger tous les ingrédients, assaisonner et garder au frais.

Au moment de servir, dresser la salade au milieu de l'assiette, couper le cuissot en tranches fines et garnir de crème fraîche aux herbes.

1 pata de jabalí
Por kg de carne:
3 cucharaditas de sal gorda
1 cucharadita de sal marina
1 cucharadita de azúcar
1 rama de tomillo, de romero y de perejil
½ cucharadita de granos de pimienta
½ cucharadita de granos de mostaza
½ cucharadita de semillas de enebro
1 hoja de laurel
Mezcle las especias, finamente machacadas, con las hierbas y frote la pata con la mezcla. Deje marinar la pata en el frigorífico durante 3–4 semanas.

120 g de judías de Kenia (finas judías verdes)
120 g de rebozuelos, limpios
1 chalote, en dados
Sal, pimienta

3 cucharadas de vinagre de vino blanco
2 cucharadas de aceite de calabaza
Escalde las judías, sofría los rebozuelos y mezcle todos los ingredientes en un cuenco. Sazone al gusto y deje reposar la mezcla durante aprox. 10 minutos.

200 g de nata fresca espesa
1 ramito de perejil, de cebollino, de mejorana y de tomillo, picados
Sal, pimienta, zumo de limón
Mezcle todos los ingredientes, sazónelos al gusto y resérvelos fríos.

Para servir coloque la ensalada en el centro del plato, corte el jamón en finas lonchas y decore con la nata con hierbas.

1 coscio di cinghiale
Per ogni kg di carne:
3 cucchiaini di salnitro
1 cucchiaino di sale marino
1 cucchiaino di zucchero
1 ramoscello di timo, 1 di rosmarino ed 1 mazzetto di prezzemolo
½ cucchiaino di grani di pepe
½ cucchiaino di grani di senape
½ cucchiaino di bacche di ginepro
1 foglia di alloro
Triturare finemente tutti gli aromi, mischiarvi le erbe e strofinare gli odori sul coscio. Lasciar marinare in frigorifero per 3–4 settimane.

120 g di fagioli del Kenya (fagiolini teneri)
120 g di funghi galletti puliti
1 scalogno tagliato a dadini
Sale, pepe

3 cucchiai di aceto di vino bianco
2 cucchiai di olio di semi di zucca
Scottare i fagiolini, rosolare i funghi e mischiare in una ciotola tutti gli ingredienti. Assaggiare, regolare il condimento e far riposare per circa 10 minuti.

200 g di crème fraîche
1 mazzetto di prezzemolo, 1 di erba cipollina, 1 di maggiorana ed 1 di timo tritati
Sale, pepe, succo di limone
Mescolare tutti gli ingredienti, assaggiare, regolare il condimento e mettere in frigo.

Disporre l'insalata nel mezzo del piatto, tagliare il prosciutto a fette sottili, guarnire con la crème fraîche alle erbe e servire.

Capricorn [i] Aries
Restaurant

Design: Judith Werner | Chef: Klaus Jaquemod | Owner: Judith Werner

Alteburgerstraße 34 | 50678 Köln | Südstadt
Phone: +49 221 32 31 82
Subway: Chlodwigplatz
Opening hours: Wen–Sun 7 pm to open end
Average price: € 35
Cuisine: French
Special features: Cook courses, Sacre Bleu music program with light show

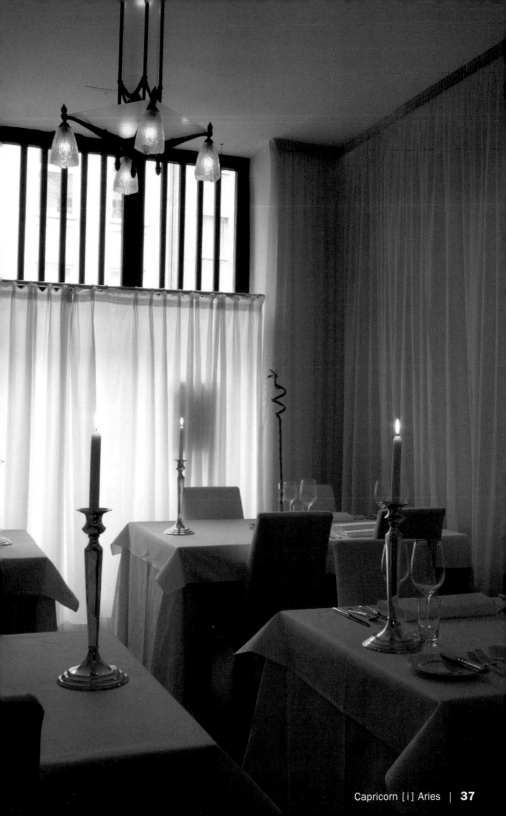

Zweierlei
vom Rind auf lila Kartoffeln

Beef Medley on Blue Potatoes

Duo de bœuf sur lit de pommes de terre Vitelotte

Dúo de ternera sobre patatas violetas

Bis di manzo con patate viola

500 g Rinderwade
Salz, Pfeffer
1 Zwiebel, gewürfelt
1 Knoblauchzehe, gehackt
Je 1 Bund Basilikum, Rosmarin, Salbei, Thymian und Majoran
1 Gewürzsäckchen (1 EL getrocknete Steinpilze, 1 Lorbeerblatt, 2 Wacholderbeeren, 1 Nelke, 5 Pfefferkörner)
250 g Rinderfilet
20 schwarze Oliven, entsteint
500 g lila Kartoffeln
7 EL Butter
2 EL Petersilie, gehackt
Verschiedene Gemüse
4 Scheiben Speck, gebraten

Die Rinderwade würzen und von beiden Seiten scharf anbraten. Beiseite stellen. Die Zwiebel und den Knoblauch in derselben Pfanne braten und mit der Rinderwade in einen mittleren Topf geben. Mit Wasser auffüllen, die Kräuter und Gewürze zugeben. Aufkochen und 30 Minuten köcheln lassen. Dann bei 80 °C 4–5 Stunden ziehen lassen. Die Kartoffeln mit Schale kochen, pellen, pürieren, mit 3 EL Butter und Petersilie mischen und abschmecken. Das Gemüse putzen, mundgerecht schneiden und blanchieren. In 4 EL Butter schwenken und würzen. Das Fleisch aus dem Sud nehmen und warm stellen. Den Sud passieren, auf 250 ml einreduzieren und abschmecken. Das Rinderfilet anbraten, die Oliven hinzugeben und mit dem Sud begießen. Ca. 5 Minuten schmoren lassen, dann mit der Wade warm stellen. Zum Servieren Kartoffelpüree in die Tellermitte geben, Gemüse ringsum verteilen, aufgeschnittene Fleischstücke darauf legen und mit Speck garnieren.

1 ¼ lb shank beef
Salt, pepper
1 onion, diced
1 garlic clove, chopped
1 bunch each of basil, rosemary, sage, thyme and marjoram
1 bouquet garni (1 tbsp dried boletus, 1 bay leaf, 2 juniper seeds, 1 clove, 5 peppercorns)
5 oz beef fillet
20 black olives, stoneless
1 lb blue potatoes
7 tbsp butter
2 tbsp parsley, chopped
Various vegetables
4 slices fried bacon

Season the shank beef and sear on both sides. Set aside. Fry the onions and garlic in the same roasting pan and transfer to a medium-roasting pan with the beef. Fill the pan with water; add the herbs and spices. Bring to the boil and allow to simmer for 30 minutes. Then allow to braise for 4–5 hours at 180 °F. Cook the potatoes in the skins, peel and mash, mix with 3 tbsp butter and parsley and season to taste. Clean the vegetables, cut to bite-size pieces and blanch. Toss in 4 tbsp butter and season. Remove the meat from the braising liquid and keep warm. Sieve the liquid; reduce to 250 ml and season to taste. Sautée the beef fillet, add the olives and pour over the remaining braising liquid. Allow to simmer for approx. 5 minutes, and then keep warm with the shank beef. To serve, place mashed potato in the center of the dish, surround with vegetables, top with the carved steak pieces and garnish with bacon.

500 g de jarret de bœuf sans os
Sel, poivre
1 oignon coupé en dés
1 gousse d'ail hachée
1 branche de basilic, 1 de romarin, 1 de sauge,
1 de thym et 1 d'origan
1 sachet d'épices (1 c. à soupe de bolets séchés,
1 feuille de laurier, 2 baies de genièvre, 1 clou de
girofle, 5 grains de poivre)
250 g de filet de bœuf
20 olives noires dénoyautées
500 g de pommes de terre Vitelotte
7 c. à soupe de beurre
2 c. à soupe de persil haché
Légumes variés
4 tranches de lard poêlé

Aromatiser le jarret de bœuf et bien le saisir de
chaque côté. Réserver. Faire revenir l'oignon et
l'ail dans la même poêle et les verser avec le
jarret dans un faitout de taille moyenne. Couvrir
d'eau, puis ajouter les herbes et les épices.
Porter à ébullition, puis laisser cuire à feu doux
30 minutes. Laisser ensuite macérer pendant
4–5 heures à 80 °C. Cuire les pommes de terre
avec la peau, les éplucher, les réduire en purée,
ajouter 3 c. à soupe de beurre, le persil, et aro-
matiser. Laver les légumes, les couper en bou-
chées et les blanchir. Les saisir légèrement dans
4 c. à soupe de beurre, puis aromatiser. Séparer
le jarret du fond et le garder au chaud. Filtrer le
fond, le réduire à 250 ml et l'aromatiser. Saisir le
filet de bœuf, ajouter les olives et arroser avec le
fond. Laisser braiser pendant 5 minutes environ,
puis garder au chaud avec le jarret. Dresser la
purée de pomme de terre au milieu de l'assiette,
disposer les légumes tout autour et les morceaux
de viande dessus. Garnir de lard.

500 g de contra de ternera
Sal, pimienta
1 cebolla, en dados
1 diente de ajo, picado
1 ramito de albahaca, romero, salvia, tomillo y
mejorana
1 bolsita de especias (1 cucharada de boletos
secos, 1 hoja de laurel, 2 enebrinas, 1 clavo, 5
granos de pimienta)
250 g de filete de ternera
20 aceitunas negras, deshuesadas
500 g de patatas violetas
7 cucharadas de mantequilla
2 cucharadas de perejil, picado
Diferentes verduras
4 lonchas de beicon, frito

Sazone la contra de ternera y fríala bien por
ambos lados. Reserve. Sofría la cebolla y el ajo
en la sartén de la carne y ponga después los
ingredientes en una cazuela mediana junto con
la contra. Llene la cazuela de agua y añada las
hierbas y las especias. Deje que hierva a fuego
lento durante 30 minutos. Después deje reposar
la carne entre 4 o 5 horas a 80 °C. Cueza las
patatas con piel, pélalas, hágalas puré, méz-
clelas con 3 cucharadas de mantequilla y con
el perejil y sazone al gusto. Limpie la verdura,
trocéela y escáldela. Saltee los trozos de ver-
dura en 4 cucharadas de mantequilla y sazone.
Saque la carne del caldo y resérvela caliente.
Pase el caldo por el pasapurés, redúzcala hasta
que queden 250 ml y sazone. Fría el filete de
ternera, añada las aceitunas y vierta por encima
el caldo. Deje que hierva a fuego lento durante
aprox. 5 minutos y resérvelo caliente junto con
la contra. Para servir ponga puré de patata en el
centro de los platos, reparta alrededor la verdura,
coloque encima la carne troceada y adorne con
el beicon.

500 g di geretto di vitello
Sale, pepe
1 cipolla tagliata a dadini
1 spicchio d'aglio tritato
1 mazzetto di basilico, 1 di rosmarino, 1 di salvia,
1 di timo ed 1 di maggiorana
1 sacchetto di erbe aromatiche (1 cucchiaio di
funghi porcini secchi, 1 foglia di alloro, 2 bacche
di ginepro, 1 chiodo di garofano, 5 grani di pepe)
250 g di filetto di manzo
20 olive nere snocciolate
500 g di patate viola
7 cucchiai di burro
2 cucchiai di prezzemolo tritato
Verdure varie
4 fette di speck arrostito

Condire il geretto di vitello e rosolarlo a fuoco vivo
da entrambi i lati. Tenerlo da parte. Imbiondire
nella stessa padella la cipolla e l'aglio e metterli
insieme al geretto in una pentola di dimensioni
medie. Ricoprire d'acqua ed unire le erbe e gli
odori. Dare un bollore e far cuocere a fuoco lento
per 30 minuti. Quindi far riposare ad 80 °C per
4–5 ore. Cuocere le patate con la buccia, spellar-
le, passarle con il passaverdura, unirvi 3 cucchiai
di burro ed il prezzemolo, assaggiare e regolare
il condimento. Lavare le verdure, tagliarle a boc-
concini e scottarle in acqua bollente. Saltarle in
4 cucchiai di burro e condirle. Estrarre la carne
dal brodo di cottura e tenerla in caldo. Passare il
brodo al setaccio, farlo restringere fino a 250 ml,
assaggiare e regolare il condimento. Rosolare il
filetto di manzo, unirvi le olive e bagnare con il
brodo. Cuocere a fuoco lento per circa 5 minu-
ti, quindi mettere in caldo insieme allo stinco.
Mettere la purea di patate al centro del piatto,
disporvi intorno le verdure, poggiarvi i bocconcini
di carne, guarnire con lo speck e servire.

CHEZ CHEF

Design: Dorothee Spitz | Chef: Raimund Musar
Owner: Armin W. Müller

Spichernstraße 77 | 50672 Köln | Stadtmitte
Phone: +49 221 6 50 36 50
www.chez-chef.de
Subway: Christophstraße, Mediapark
Opening hours: Mon–Fri 10 am to 1 am, Sat–Sun 6 pm to 1 am
Average price: € 14
Cuisine: Crossover
Special features: Located in an old weights and measures office

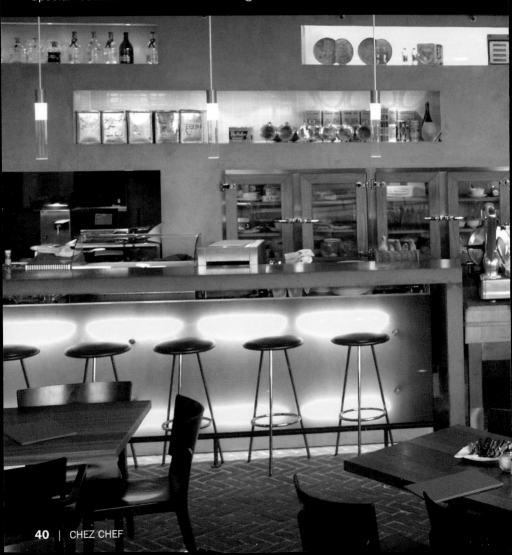

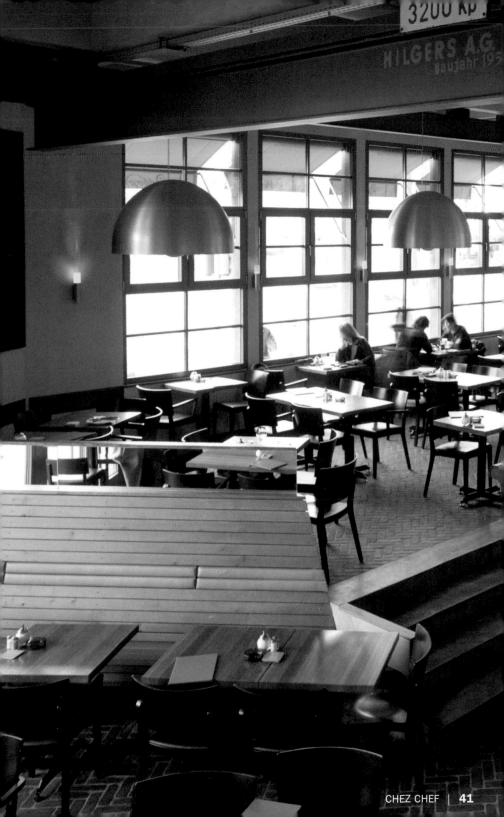

Nippon-Tunfisch

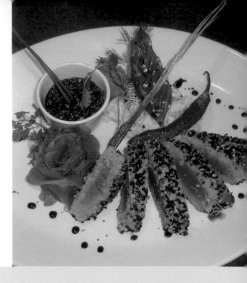

Nippon Tuna Fish

Thon nippon

Atún japonés

Tonno alla giapponese

4 Stück Tunfisch, à 180 g
Salz, Pfeffer
1 EL Limettensaft
Je 3 EL weißer und schwarzer Sesam
3 EL Sesamöl

400 g Kartoffelpüree
2 EL Wasabi
4 EL Schnittlauch, geschnitten
100 ml Sojasauce
6 EL eingelegter Ingwer
Verschiedene Kräuter zur Dekoration

Kartoffelpüree mit Wasabi mischen und beiseite stellen. Schnittlauch mit der Sojasauce mischen und in vier Schälchen füllen. Beiseite stellen. Aus dem eingelegten Ingwer vier Rosen formen und beiseite stellen.
Den Tunfisch mit Salz, Pfeffer und Limettensaft würzen und in Sesam wälzen. Das Öl in einer großen Pfanne erhitzen und die Tunfischstücke von beiden Seiten 1 Minute scharf anbraten. Während dessen Kartoffelpüree, Ingwerrosen und den Sojadip auf vier Tellern arrangieren, die Tunfischstücke in Scheiben schneiden und auf den Tellern anrichten. Mit frischen Kräutern garnieren.

4 tuna steaks, 6 oz each
Salt, pepper
1 tbsp lime juice
3 tbsp each of white and black sesame
3 tbsp sesame oil

1 lb mashed potato
2 tbsp Wasabi
4 tbsp chives, chopped
100 ml soy sauce
6 tbsp pickled ginger
Various herbs for decoration

Mix the mashed potato and Wasabi and set aside. Mix the chives with the soy sauce and divide into 4 dishes. Set aside.
Shape four roses out of the pickled ginger and set aside. Season the tuna fish with salt, pepper and lime juice and toss in the sesame. Heat the oil in a large pot and sear the tuna steaks on both sides for 1 minute. Meanwhile, arrange the mashed potato, ginger roses and soy dip on four plates, slice the tuna steaks and set out on the plates. Garnish with fresh herbs.

4 morceaux de thon de 180 g
Sel, poivre
1 c. à soupe de jus de citron vert
3 c. à soupe de sésame blanc et 3 de sésame noir
3 c. à soupe d'huile de sésame

400 g de purée de pommes de terre
2 c. à soupe de wasabi
4 c. à soupe de ciboulette coupée
100 ml de sauce soja
6 c. à soupe de gingembre mariné
Herbes variées pour la garniture

Mélanger la purée de pommes de terre et le wasabi, puis réserver. Mélanger la ciboulette et la sauce soja et verser dans quatre petites coupelles. Réserver. Former quatre roses avec le gingembre et réserver.
Saler et poivrer le thon, l'assaisonner de jus de citron vert et le rouler dans le sésame. Faire revenir l'huile dans une grande poêle et bien saisir les morceaux de thon de chaque côté pendant 1 minute. Pendant ce temps, dresser la purée, les roses de gingembre et le dip de soja sur quatre assiettes, couper ensuite les morceaux de thon en tranches et les disposer au milieu. Garnir d'herbes fraîches.

4 trozos de atún, de 180 g cada uno
Sal, pimienta
1 cucharada de zumo de lima
3 cucharadas de sésamo blanco y 3 de sésamo negro
3 cucharadas de aceite de sésamo

400 g de puré de patata
2 cucharadas de wasabi
4 cucharadas de cebollino, cortado
100 ml de salsa de soja
6 cucharadas de jengibre marinado
Diferentes hierbas para decorar

Mezcle el puré de patata con el wasabi y reserve. Mezcle el cebollino con la salsa de soja y llene cuatro cuencos con la mezcla. Reserve. Haga 4 rosas del jengibre marinado y reserve.
Sazone el atún con sal, pimienta y el zumo de lima. Rebócelo después en las semillas de sésamo. Caliente el aceite en una sartén grande y fría los trozos de atún a fuego fuerte durante 1 minuto por cada lado. Mientras, disponga el puré de patata, las rosas de jengibre y la mezcla de soja en cuatro platos, corte el atún en lonchas y colóquelas en los platos. Decore con hierbas frescas.

4 tranci di tonno da 180 g ciascuno
Sale, pepe
1 cucchiaio di succo di limetta
3 cucchiai di sesamo bianco e 3 cucchiai di sesamo nero
3 cucchiai di olio di sesamo

400 g di purea di patate
2 cucchiai di wasabi
4 cucchiai di erba cipollina sminuzzata
100 ml di salsa di soia
6 cucchiai di zenzero in conserva
Per la guarnizione: erbe aromatiche

Mescolare la purea di patate ed il wasabi e tenere da parte il composto. Mescolare l'erba cipollina e la salsa di soia e versarle in quattro ciotoline. Tenerle da parte. Ricavare quattro rose dallo zenzero in conserva e tenerle da parte.
Condire il tonno con sale, pepe e succo di limetta e passarlo nel sesamo. In una grossa padella, riscaldare l'olio e rosolarvi i tranci di tonno a fuoco vivo da entrambi i lati per circa 1 minuto. Nel frattempo, mettere in quattro piatti la purea di patate, le rose di zenzero e l'intingolo di soia, tagliare a fette i tranci di tonno e disporli nei piatti. Guarnire con erbe aromatiche fresche.

DINNERCLUB

Design: Thomas Wenzel, Stefan Meßner | Chef: Dirk Haase
Owner: F&Bconcept KG

Alteburgerstraße 11 | 50678 Köln | Südstadt
Phone: +49 221 1 30 07 25
www.dinnerclub-cologne.de
Subway: Chlodwigplatz
Opening hours: Mon–Sat 7 pm to open end, Sun closed
Menu price: € 30
Cuisine: Crossover
Special features: Daily live acts, each Wednesday Funky Plüsch Party and exhibitions

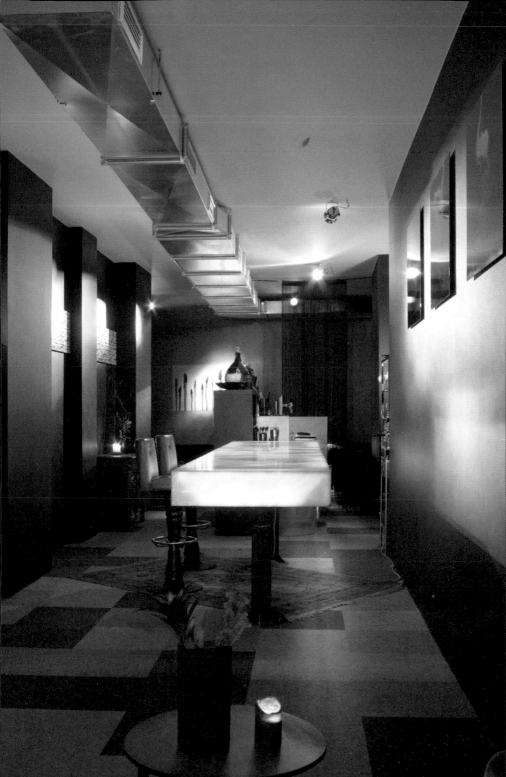

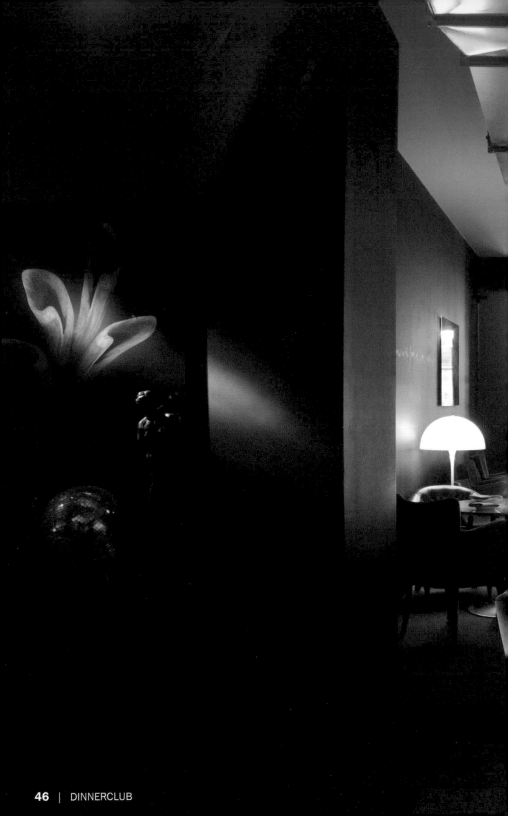

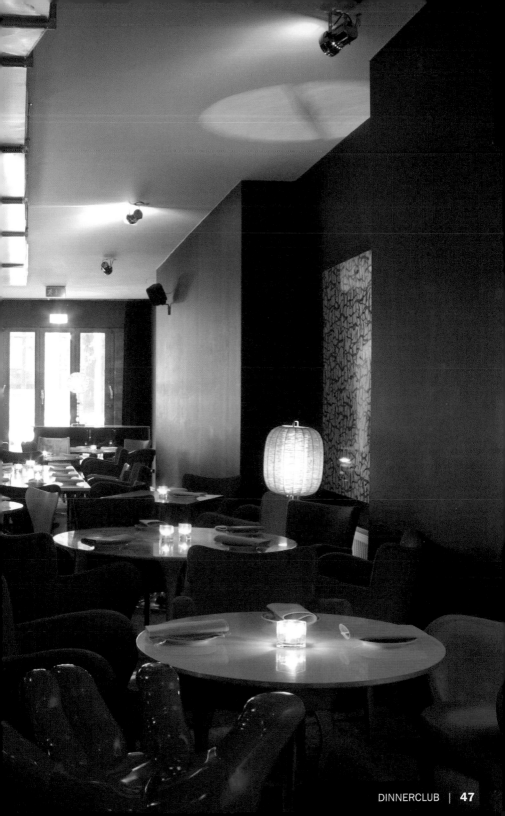

DIVAS
Wintergartenrestaurant

Design: Gisela Ragge | Chef: Mr. Alexander | Owner: Gisela Ragge

Turinerstraße 9 | 50668 Köln | Altstadt Nord
Phone: +49 221 1 62 30
www.savoy.de
Subway: Hauptbahnhof
Opening hours: Mon–Sun noon to midnight
Average price: € 20
Cuisine: International
Special features: Inspiring mix of color & light

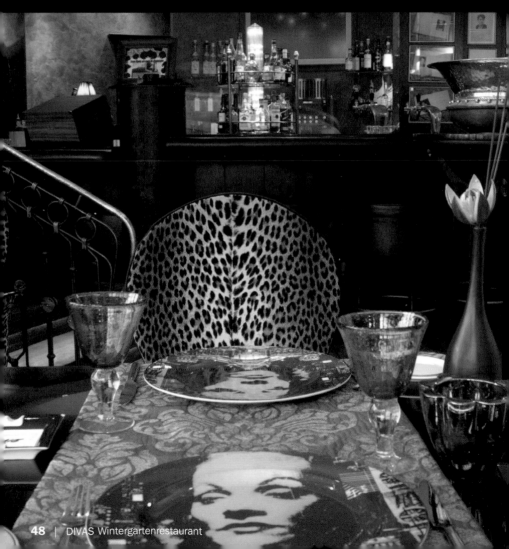

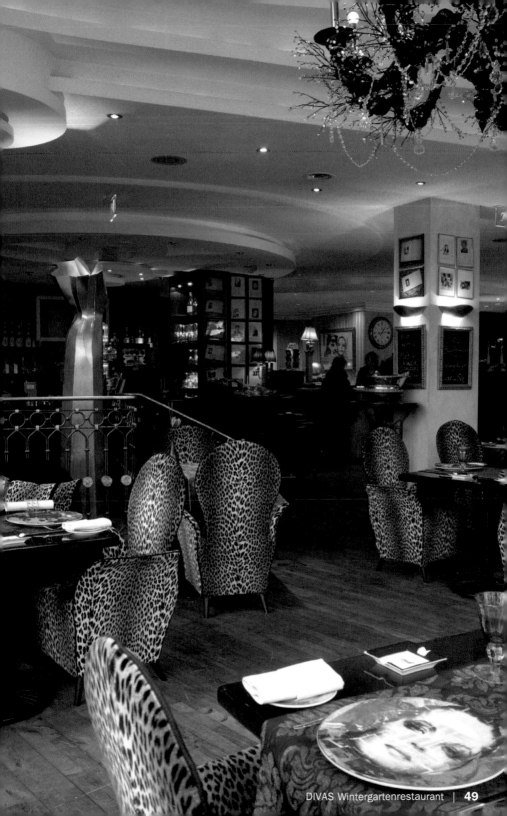

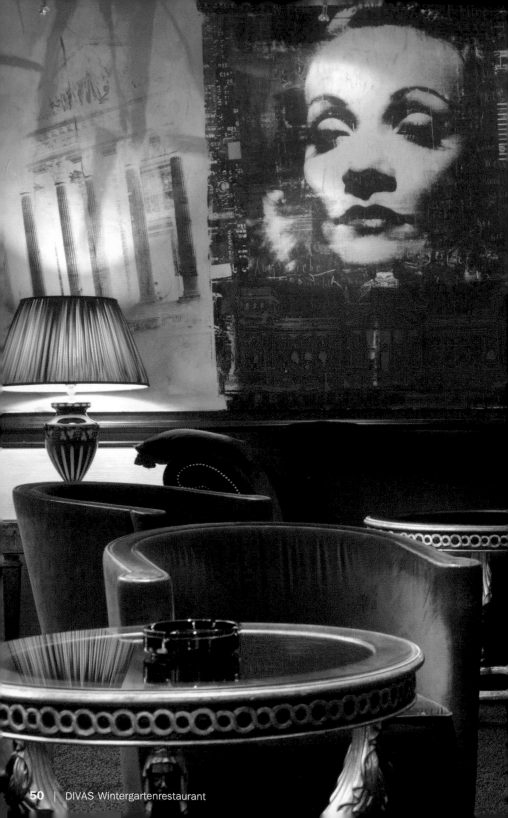

Alligator-Zitronen-gras-Spieß auf Gemüse

Alligator Lemon Grass Spits on Vegetables

Brochette d'alligator sur lit de légumes

Brocheta de aligator con limoncillo sobre verdura

Spiedini di alligatore e cedronella con verdure

500 g Alligatorhackfleisch
100 g Schweinehackfleisch (Oberschale)
2 Eier
1 Zwiebel, fein gewürfelt
1 Knoblauchzehe, gehackt
Salz, Pfeffer
Semmelbrösel
12 Stangen Zitronengras
3 EL Pflanzenöl

Alle Zutaten miteinander vermischen und je nach Bedarf Semmelbrösel hinzufügen, bis die Masse noch saftig, aber nicht mehr klebrig ist. 24 Küchlein formen und in Öl von beiden Seiten 5 Minuten anbraten.

Die Nuggets auf das Zitronengras stecken und mit Gemüse der Saison servieren.

1 lb alligator mince
3 ½ oz pork mince (topside)
2 eggs
1 onion, finely diced
1 garlic clove, chopped
Salt, pepper
Breadcrumbs
12 spears of lemon grass
3 tbsp vegetable oil

Mix all the ingredients with each other and add the breadcrumbs, as required, until the mixture is still juicy, but no longer sticky. Shape into 24 small cakes and sautée in the oil on both sides for 5 minutes.

Place the nuggets on the lemon grass and serve with vegetables of the season.

500 g de viande hachée d'alligator
100 g de hachis de porc (jambon)
2 œufs
1 oignon coupé en petits dés
1 gousse d'ail hachée
Sel, poivre
Chapelure
12 branches de citronnelle
3 c. à soupe d'huile végétale

Mélanger tous les ingrédients et ajouter la chapelure de sorte que la masse reste juteuse, mais non collante. Former 24 petites boulettes et les faire revenir dans l'huile 5 minutes de chaque côté.

Piquer les nuggets sur les branches de citronnelle et servir avec les légumes de saison.

500 g de carne picada de aligator
100 g de carne picada de cerdo (tapa)
2 huevos
1 cebolla, en dados pequeños
1 diente de ajo, picado
Sal, pimienta
Migas de pan
12 ramitas de limoncillo
3 cucharadas de aceite vegetal

Mezcle todos los ingredientes y añada las migas de pan que necesite hasta que la masa siga estando jugosa pero no pegajosa. Forme 24 pastelillos y fríalos en el aceite durante 5 minutos por cada lado

Inserte los pastelillos en las ramas de limoncillo y sirva con verdura de temporada.

500 g di carne di alligatore tritata
100 g di carne di maiale tritata (controgirello)
2 uova
1 cipolla tagliata a dadini piccoli
1 spicchio d'aglio tritato
Sale, pepe
Pangrattato
12 bastoncini di cedronella
3 cucchiai di olio vegetale

Mescolare tutti gli ingredienti ed unirvi il pangrattato in quantità tale da ottenere un composto morbido ma non appiccicoso. Ricavare 24 frittelle e friggerle in olio per 5 minuti da entrambi i lati.

Infilzarle sui bastoncini di cedronella e servire gli spiedini con verdure di stagione.

Fischermanns'

Design: Armand-Michael Klein | Chef: Mitsuru Watanabe
Owner: Robert Fischermann

Rathenauplatz 21 | 50674 Köln | Quartier Latin
Phone: +49 221 8 01 77 90
www.fischermanns.com
Subway: Zülpicher Platz
Opening hours: Mon–Sun 6 pm to open end
Average price: € 13.50
Cuisine: European Asian
Special features: Strawberry Tiramisu

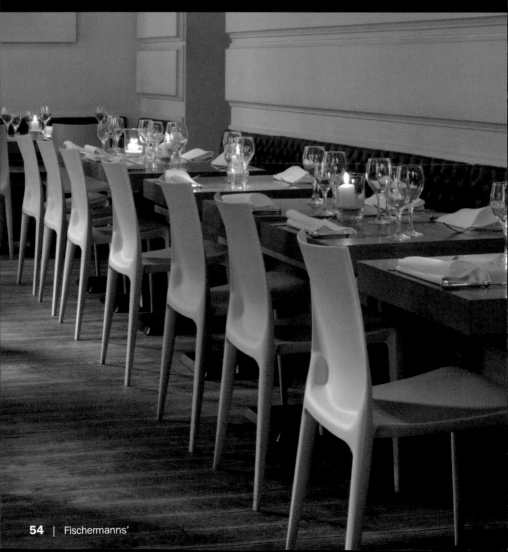

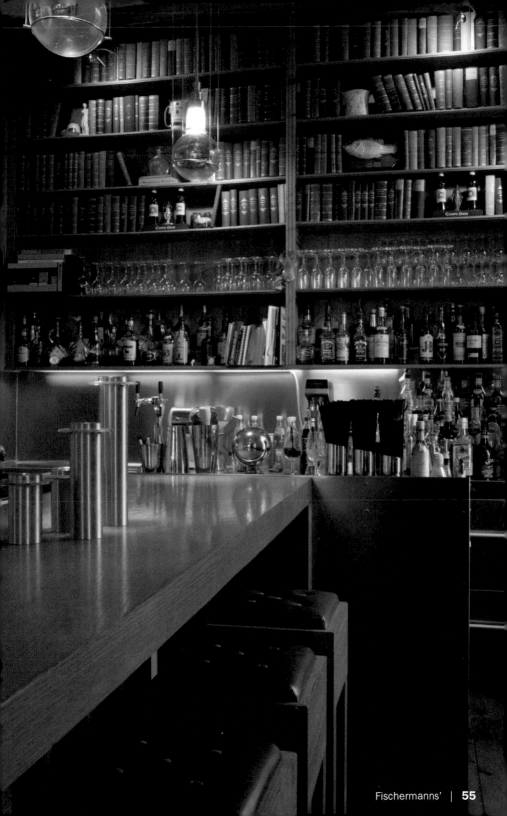

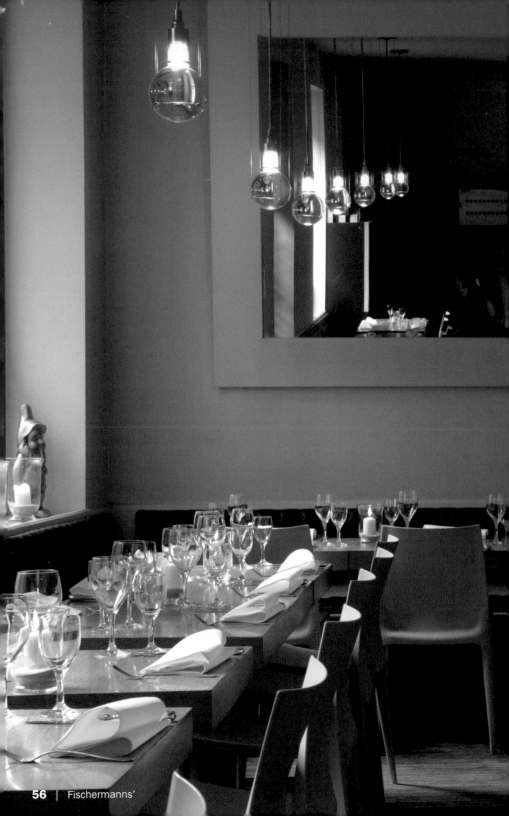

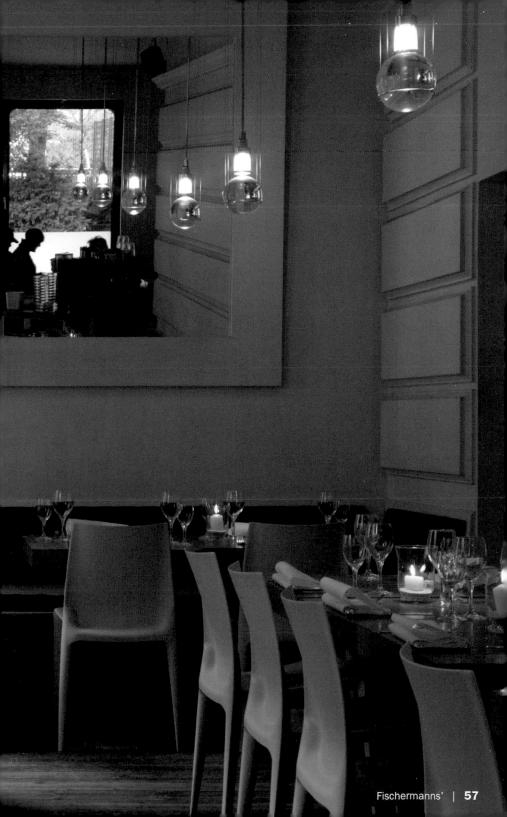

Graugans

Design: HBA, Hirsch Bedner Associates| Chef: Roland Brandtner
Owner: Hyatt Regency Köln

Kennedy-Ufer 2a | 50679 Köln | Deutz
Phone: +49 221 82 81 17 71
www.cologne.regency.hyatt.de
Subway: Deutzer Bahnhof
Opening hours: Mon–Fri noon to 2:30 pm, 6:30 pm to open end, Sun closed
Average price: € 32
Cuisine: European Asian
Special features: The view onto Rhine river, cathedral and old town

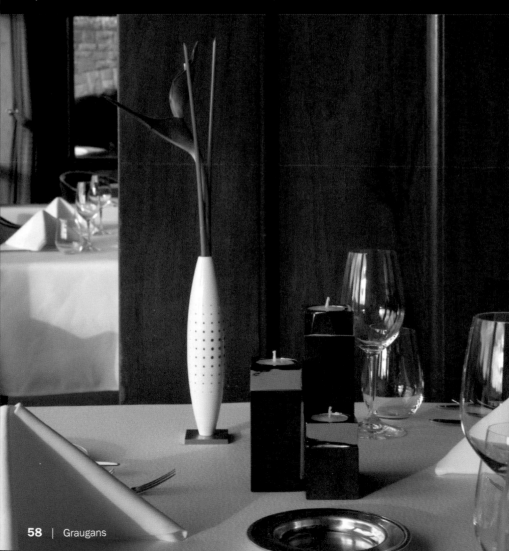

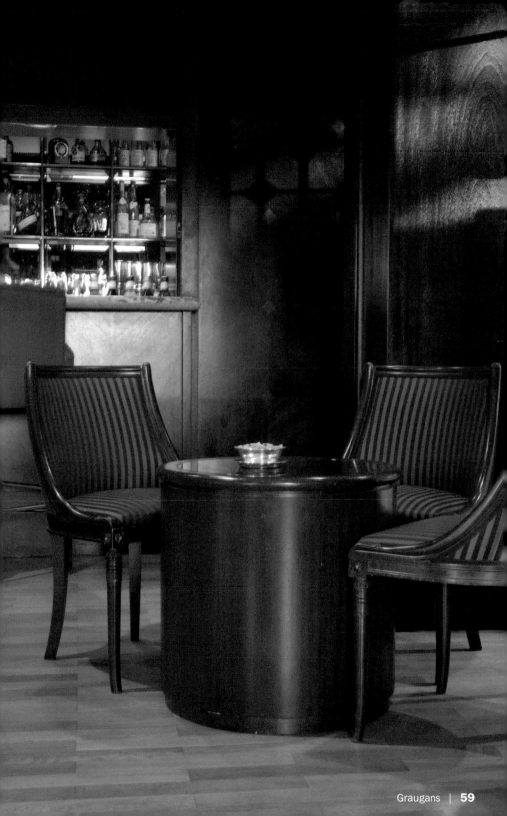

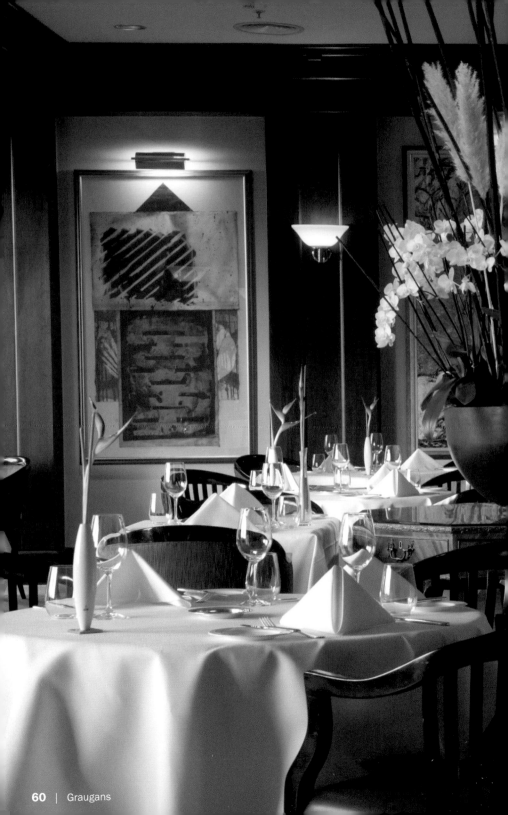

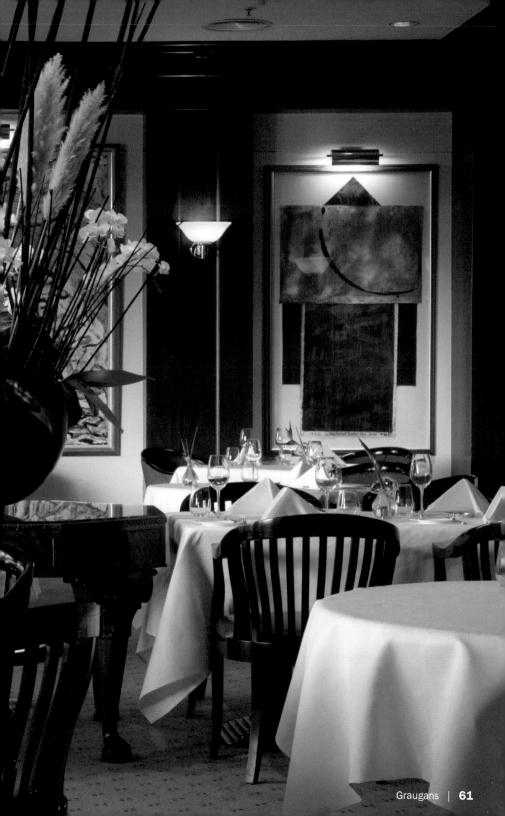

Harry's New-York Bar

Design: k/h Büro für Innenarchitektur und Design
Chef: Jörg Stricker | Owner: InterContinental Köln

Pipinstraße 1 | 50667 Köln | Stadtmitte
Phone: +49 221 2 80 60
www.cologne.intercontinental.com
Subway: Heumarkt, Neumarkt
Opening hours: Sun–Thu 10 am to 2 am, Fri–Sat 10 am to open end
Average price: € 11
Cuisine: American
Special features: Live music every night except Sunday

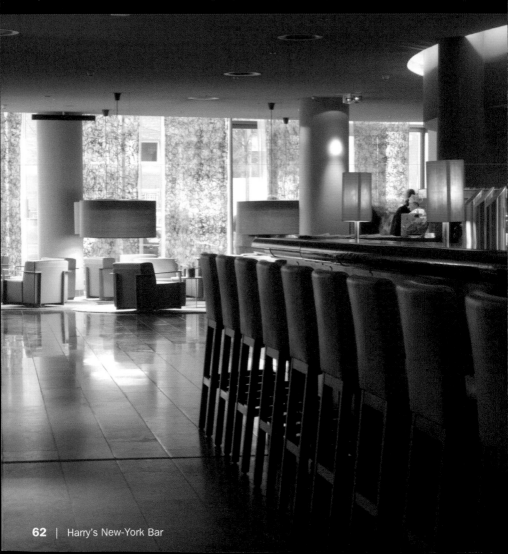

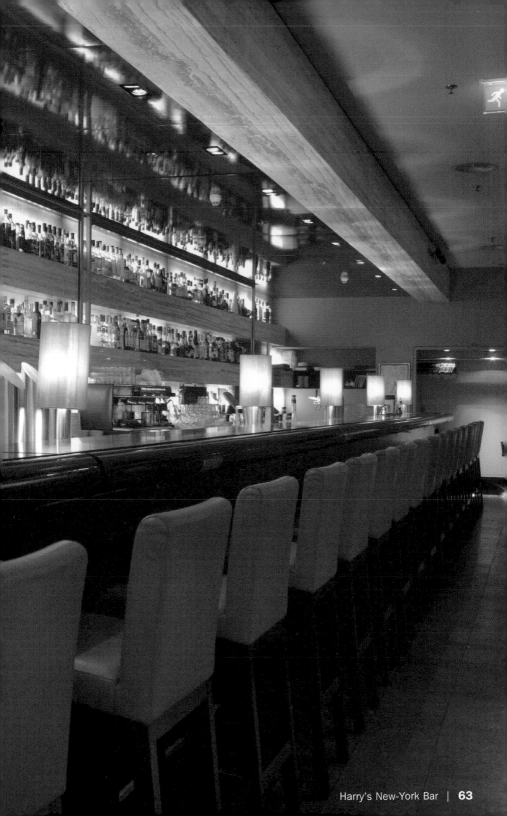

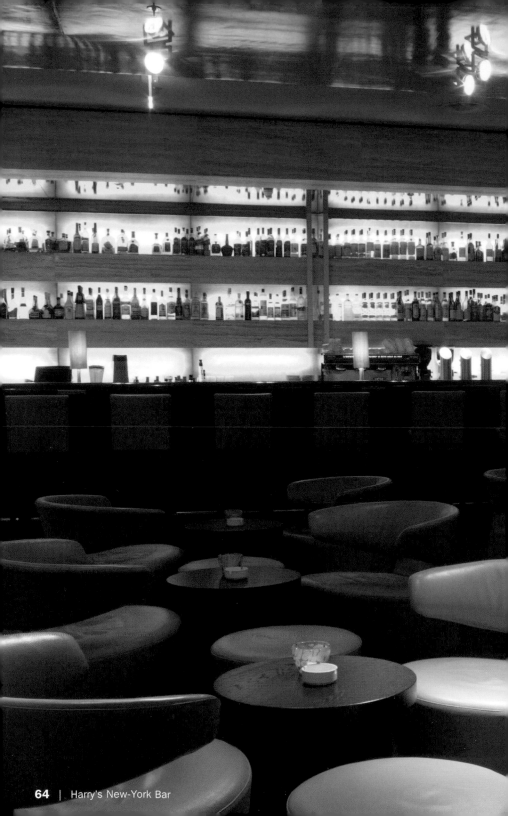

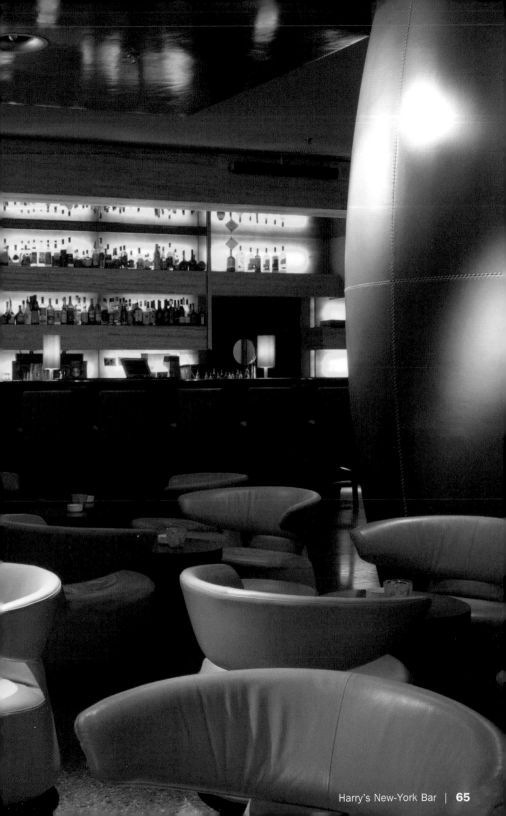

Holtmann's Restaurant

Design: Henriette Holtmann | Chef: Stephane Suarez
Owner: Michael Holtmann

Am Bollwerk 21 | 50667 Köln | Altstadt
Phone: +49 221 57 63 30
www.holtmanns.com
Subway: Hauptbahnhof
Opening hours: Mon–Sun noon to midnight
Average price: € 50
Cuisine: International
Special features: Fresh seafood, fillet of beef, quality meats

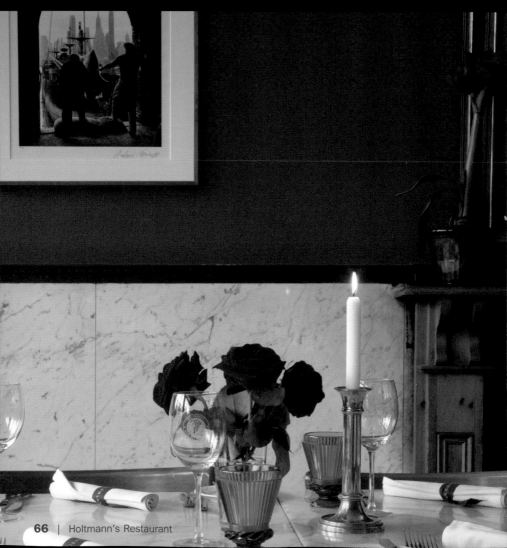

Jungschweinkeule
mit Malzbiersauce

Leg of Young Pork with Malt Beer Sauce

Gigot de porcelet à la bière de malt

Pata de cochinillo con salsa de cerveza de malta

Cosciotto di maialino in salsa di birra al malto

1½ kg Keule vom Jungschwein, den Knochen ausgelöst
2 EL Senf
Salz, Pfeffer
6 EL Pflanzenöl
1 Flasche Malzbier
500 g Fleischabschnitte
1 Karotte, gewürfelt
1 kleiner Knollensellerie, gewürfelt
2 Zwiebeln, gewürfelt
1 Lauch, in Streifen
1 Petersilienwurzel, gewürfelt
1 Lorbeerblatt
8 Pfefferkörner, zerdrückt
Sauerkraut, Kartoffeln, verschiedene Gemüse

Den ausgelösten Braten mit Senf bestreichen und würzen. 3 EL Öl in einer Pfanne erhitzen und den Braten von allen Seiten scharf anbraten. Den Braten bei 180 °C ca. 20 Minuten schmoren, dabei alle 5 Minuten mit Malzbier übergießen. Zum Schluss die Kruste einschneiden und 5 Minuten kross braten.
Die Fleischabschnitte und den ausgelösten Knochen in 3 EL Öl rundum anbraten, das Gemüse und die Gewürze dazugeben und 5 Minuten weiter braten. Mit Malzbier 4–5 mal ablöschen und immer wieder einreduzieren lassen. Dann Wasser hinzufügen und mit Salz würzen. Die Flüssigkeit zur Hälfte einkochen lassen. Den Saucenfond durch ein Sieb gießen, das Fett abschöpfen und den Fond abschmecken. Evtl. noch weiter reduzieren.
Das Fleisch in Scheiben schneiden und mit Sauerkraut, Kartoffelpüree, verschiedenen Gemüsen und der Sauce servieren.

3 ¾ lb leg of young pork, off the bone (reserve bone for stock)
2 tbsp mustard
Salt, pepper
6 tbsp vegetable oil
1 bottle malt beer
1 lb meat cuts
1 carrot, diced
1 small root celery, diced
2 onions, diced
1 leek, in strips
1 root parsley, diced
1 bay leaf
8 peppercorns, crushed
Sauerkraut, potatoes, various vegetables

Coat the boneless joint with mustard and season. Heat 3 tbsp of oil in a roasting pan and sear the meat on all sides. Braise the joint at 350 °F for approx. 20 minutes, pouring over malt beer every 5 minutes. Finally, score the crackling and roast for 5 minutes until crispy.
Sautée the meat cuts and the bone all round in 3 tbsp of oil, add the vegetables and the spices and fry for a further 5 minutes. Drench with malt beer 4–5 times and continually reduce down the liquid. Then add water and season with salt. Allow half of the liquid to boil down. Pour the stock for the sauce through a sieve, spoon off the fat and season the stock. Reduce further if necessary.
Carve the meat in slices and serve with Sauerkraut, mashed potato, various vegetables and the sauce.

1½ kg de gigot de porcelet désossé, garder l'os
2 c. à soupe de moutarde
Sel, poivre
6 c. à soupe d'huile végétale
1 bouteille de bière de malt
500 g de restes de viande
1 carotte coupée en dés
1 petit céleri-rave coupé en dés
2 oignons coupés en dés
1 poireau en lamelles
1 racine de persil coupée en dés
1 feuille de laurier
8 grains de poivre concassés
Choucroute, pommes de terre, légumes variés

Badigeonner de moutarde le rôti désossé et l'aromatiser. Faire chauffer 3 c. à soupe d'huile dans une poêle et revenir le rôti sur toutes ses faces. Ensuite braiser le rôti à 180 °C pendant 20 minutes environ en l'arrosant de bière de malt toutes les 5 minutes. Inciser enfin la croûte et cuire le rôti de sorte qu'il soit croustillant.
Faire revenir les restes de viande et l'os du gigot dans 3 c. à soupe d'huile, ajouter les légumes et les épices et poursuivre la cuisson 5 minutes. Mouiller 4–5 fois de bière et laisser continuellement réduire. Puis ajouter de l'eau et saler. Réduire le liquide de moitié. Passer le fond au tamis, le dégraisser et l'assaisonner. Le laisser éventuellement réduire encore.
Couper la viande en tranches et servir avec la choucroute, la purée de pommes de terre, les légumes variés et la sauce.

1½ kg de pata de cochinillo, deshuesada pero reservando el hueso
2 cucharadas de mostaza
Sal, pimienta
6 cucharadas de aceite vegetal
1 botella de cerveza de malta
500 g de carne en trozos
1 zanahoria, en dados
1 bulbo de apio pequeño, en dados
2 cebollas, en dados
1 puerro, en juliana
1 raíz de perejil, en dados
1 hoja de laurel
8 granos de pimienta, machacados
Col agria, patatas, diferentes tipos de verdura

Pinte la pata de cochinillo con la mostaza y sazone. Caliente 3 cucharadas de aceite en una sartén y fría bien la carne por todos los lados. Deje después que se estofe a fuego lento durante aprox. 20 minutos a 180 °C. Vierta por encima cerveza de malta cada 5 minutos. Finalmente haga cortes en la corteza y siga friendo hasta que la carne esté bien hecha.
Fría los trozos de carne y el hueso en 3 cucharadas de aceite, añada la verdura y las especias y deje que siga asándose durante 5 minutos. Vierta por encima cerveza de malta 4 o 5 veces y deje que se reduzca. Añada después agua y condimente con sal. Deje que el líquido se reduzca a la mitad. Pase el caldo por el colador, retire la grasa y salpimente. Si fuese necesario redúzcalo más.
Corte la carne en filetes y sirva con la col agria, el puré de patata, las verduras y la salsa.

1½ kg di cosciotto di maialino disossato (tenere da parte le ossa)
2 cucchiai di senape
Sale, pepe
6 cucchiai di olio vegetale
1 bottiglia di birra al malto
500 g di carne tagliata a pezzetti
1 carota tagliata a dadini
1 piccolo sedano rapa tagliato a dadini
2 cipolle tagliate a dadini
1 porro tagliato a listarelle
1 radice di prezzemolo tagliata a dadini
1 foglia di alloro
8 grani di pepe pestati
Crauti, patate, verdure varie

Spalmare di senape l'arrosto disossato e condirlo. Scaldare in una padella 3 cucchiai di olio e rosolarvi l'arrosto a fuoco vivo da tutti i lati. Cuocerlo a 180 °C per circa 20 minuti coprendolo di birra ogni 5 minuti. Infine incidere la crosta e cuocerlo per 5 minuti fino a renderlo croccante.
Dorare da tutte le parti i tocchetti di carne e le ossa in 3 cucchiai di olio, unirvi le verdure e gli aromi e rosolare il tutto per altri 5 minuti. Bagnare 4–5 volte con la birra al malto, facendo restringere ogni volta. Aggiungere l'acqua e salare. Far restringere il liquido fino alla metà. Passare il sugo al setaccio, sgrassarlo, assaggiare e regolare il condimento. Eventualmente, lasciarlo restringere ancora.
Tagliare la carne a fette e servirla con i crauti, la purea di patate, le verdure e il sugo.

HOPPER Restaurant et cetera

Design: Rolf Kursawe | Chef: Christian Grindler
Owner: PRO GAST GmbH

Brüsseler Straße 26 | 50674 Köln | Belgisches Viertel
Phone: +49 221 92 44 05 00
www.hopper.de
Subway: Rudolfplatz
Opening hours: Mon–Fri 7 am to open end, Sat 7 am to 11 am, 6 pm to open end,
Sun 7 am to 11 am
Average price: € 17.50
Cuisine: Crossover
Special features: Located in a former monastic church

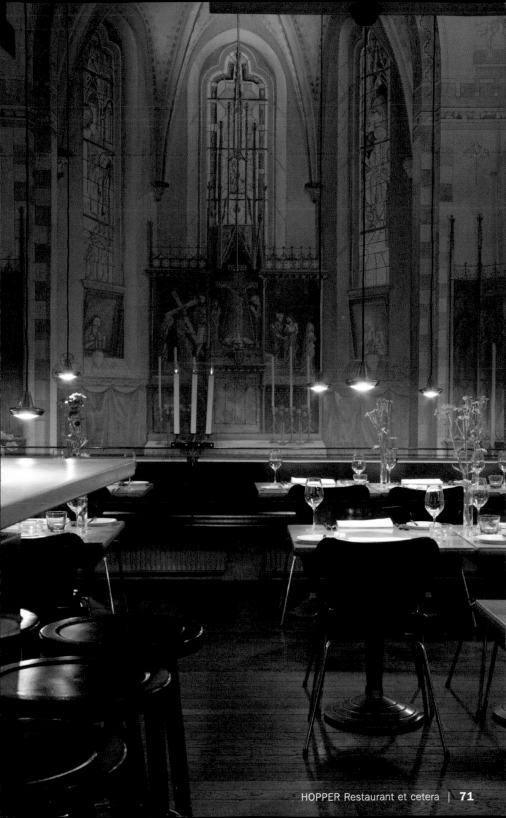

Gratinierte
Steinpilzcreme
mit Kürbis-Chutney

Boletus-Crème Gratin with Pumpkin Chutney

Crème de cèpes gratinée et chutney de potiron

Crema de boletos gratinada con chutney de calabaza

Crema gratinata di funghi porcini con chutney alla zucca

300 ml Sahne
100 g Steinpilze, geputzt
1 TL Majoran
1 TL Rosmarin
½ TL Vanille
1 EL Cognac
Salz, Pfeffer, Zimt, Muskat
3 Eigelbe
Brauner Zucker zum Gratinieren

Sahne mit Steinpilzen, Kräutern, Gewürzen und Cognac aufkochen und abschmecken. Abkühlen lassen und mit den Eigelben mischen. Über Nacht im Kühlschrank ziehen lassen. Die Mischung durch ein Sieb gießen, in vier Backförmchen geben und im Wasserbad bei 100 °C ca. 25 Minuten pochieren. Bei Zimmertemperatur abkühlen lassen. Zum Servieren mit braunem Zucker bestreuen und mit einem Bunsenbrenner gratinieren.

1 kleiner Hokkaido-Kürbis
2 EL Zucker
1 Schalotte, gewürfelt
1 getrocknete Chili
120 ml Orangensaft
Salz, Pfeffer, Koriander, Zimt, Ingwer, Muskat
2 EL Butter
Frischer Schnittlauch zum Dekorieren

Den Kürbis schälen und in Würfel schneiden. Den Zucker karamellisieren lassen und die Schalotte darin anschwitzen. Die Kürbiswürfel und die Chili dazugeben und mit Orangensaft ablöschen. 10 Minuten köcheln lassen und mit den Gewürzen abschmecken. Mit einem Pürierstab kurz mixen und mit Butter und Schnittlauch verfeinern.

300 ml cream
4 oz boletus, cleaned
1 tsp marjoram
1 tsp rosemary
½ tsp vanilla
1 tbsp cognac
Salt, pepper, cinnamon, nutmeg
3 egg yolks
Brown sugar for the gratin

Bring the cream to the boil with the boletus, herbs, spices and cognac and season to taste. Allow to cool and mix with the egg yolks. Allow to rest overnight in the refrigerator. Pour the mixture through a sieve, spoon into four small baking forms and poach in a bain-marie at 210 °F for approx. 25 minutes. Allow to cool at room temperature. To serve, sprinkle with brown sugar and gratin with a Bunsen burner.

1 small Hokkaido (Japanese) pumpkin
2 tbsp sugar
1 shallot, diced
1 dried chili
120 ml orange juice
Salt, pepper, coriander, cinnamon, ginger, nutmeg
2 tbsp butter
Fresh chives for decoration

Peel and dice the pumpkin. Allow the sugar to caramelize and lightly sautée the shallot in it. Add the diced pumpkin and chili and drench with orange juice. Allow to simmer for 10 minutes and season to taste with the spices. Briefly mix with a hand blender and finish with butter and chives.

300 ml de crème liquide
100 g de cèpes nettoyés
1 c. à café d'origan
1 c. à café de romarin
½ c. à café de vanille
1 c. à soupe de cognac
Sel, poivre, cannelle, noix de muscade
3 jaunes d'œuf
Sucre brun pour gratiner

Porter à ébullition la crème liquide, les cèpes, les herbes, les épices, le cognac et assaisonner le tout. Laisser refroidir, puis mélanger les jaunes d'œuf. Laisser macérer toute une nuit au réfrigérateur. Passer le mélange au tamis et le répartir dans quatre petits moules. Pocher le contenu des moules en le cuisant au bain-marie pendant 25 minutes à 100 °C. Laisser refroidir à température ambiante. Au moment de servir, saupoudrer de sucre et gratiner avec un bec Bunsen.

1 petit potiron d'Hokkaido
2 c. à soupe de sucre
1 échalote coupée en dés
1 piment rouge séché
120 ml de jus d'orange
Sel, poivre, coriandre, cannelle, gingembre, noix de muscade
2 c. à soupe de beurre
Ciboulette fraîche pour la garniture

Éplucher le potiron et couper la chair du potiron en dés. Caraméliser le sucre et laisser suer l'échalote. Ajouter les dés de potiron et le piment, et déglacer avec du jus d'orange. Laisser mijoter 10 minutes et aromatiser. Mélangez un court instant au mixer et ajouter beurre et ciboulette.

300 ml de nata
100 g de boletos, limpios
1 cucharadita de mejorana
1 cucharadita de romero
½ cucharadita de vainilla
1 cucharada de coñac
Sal, pimienta, canela, nuez moscada
3 yemas de huevo
Azúcar moreno para gratinar

Hierva la nata con los boletos, las hierbas, las especias, el coñac y sazone. Deje enfriar los ingredientes y mézclelos con las yemas. Deje reposar la mezcla durante la noche en el frigorífico. Después pásela por el colador, repártala en cuatro moldes pequeños y hiérvala al baño maría durante aprox. 25 minutos a 100 °C. Deje que se enfríe hasta que alcance la temperatura ambiente. Para servir esparza por encima el azúcar moreno y gratine con un soplete de cocina.

1 calabaza Hokkaido pequeña
2 cucharadas de azúcar
1 chalote, en dados
1 guindilla seca
120 ml de zumo de naranja
Sal, pimienta, cilantro, canela, jengibre, nuez moscada
2 cucharadas de mantequilla
Cebollino fresco para decorar

Pele la calabaza y córtela en dados. Caramelice el azúcar y rehogue en él el chalote. Añada los dados de calabaza y la guindilla y vierta por encima el zumo de naranja. Deje hervir los ingredientes a fuego lento durante 10 minutos y sazone con las especias. Páselo brevemente por el pasapurés y refine con mantequilla y cebollino.

300 ml di panna
100 g di funghi porcini puliti
1 cucchiaino di maggiorana
1 cucchiaiono di rosmarino
½ cucchiaino di vaniglia
1 cucchiaio di cognac
Sale, pepe, cannella, noce moscata
3 tuorli d'uovo
Zucchero bruno per gratinare

Portare a cottura la panna con i funghi, le erbe, gli aromi e il cognac, assaggiare e regolare il condimento. Lasciar raffreddare e mescolare con i tuorli d'uovo. Far riposare in frigorifero per una notte. Passare il composto al setaccio, versarlo in quattro stampini e cuocere a bagnomaria a 100 °C per circa 25 minuti. Lasciar raffreddare a temperatura ambiente. Al momento di servire, cospargere la crema di zucchero bruno e gratinarla con il becco di Bunsen.

1 piccola zucca Hokkaido
2 cucchiai di zucchero
1 scalogno tagliato a dadini
1 peperoncino secco
120 ml di succo di arancia
Sale, pepe, coriandolo, cannella, zenzero, noce moscata
2 cucchiai di burro
Per la guarnizione: erba cipollina fresca

Sbucciare e tagliare a pezzetti la zucca. Caramellizzare lo zucchero e rosolarvi lo scalogno. Unire i pezzi di zucca ed il peperoncino e bagnare con il succo d'arancia. Cuocere a fuoco lento per 10 minuti, assaggiare ed aggiungere gli aromi. Frullare brevemente ed insaporire con burro ed erba cipollina.

HoteLux

Design: Mariusz Becker | Chef: Piotr Redzimski
Owners: Sylvia Becker, Mariusz Becker

Von-Sandt-Platz 10 | 50679 Köln | Deutz
Phone: +49 221 24 11 36
www.hotelux.de
Subway: Köln Arena, Köln Messe
Opening hours: Sun–Thu 6 pm to 1 am, Fri–Sat 6 pm to 3 am
Average price: € 14
Cuisine: Russian, Soviet
Special features: The ideal place for a twosome dinner with candle light

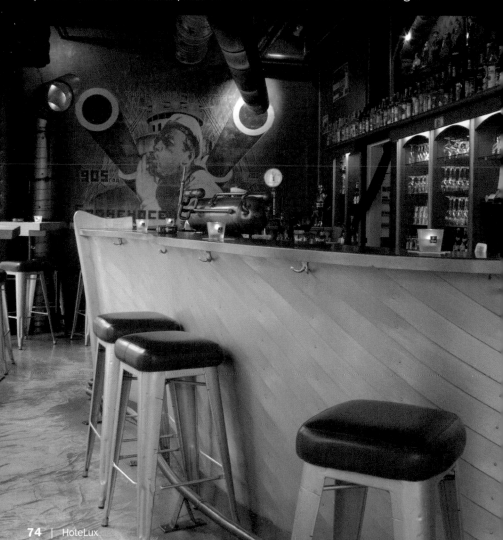

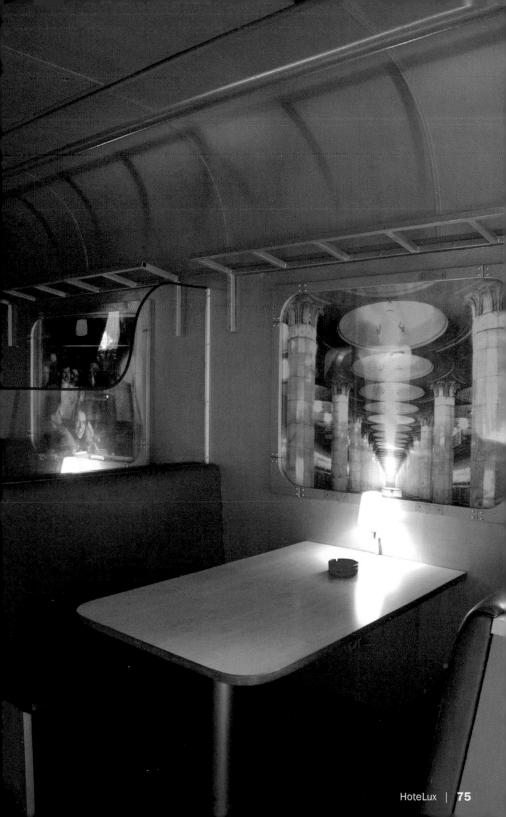

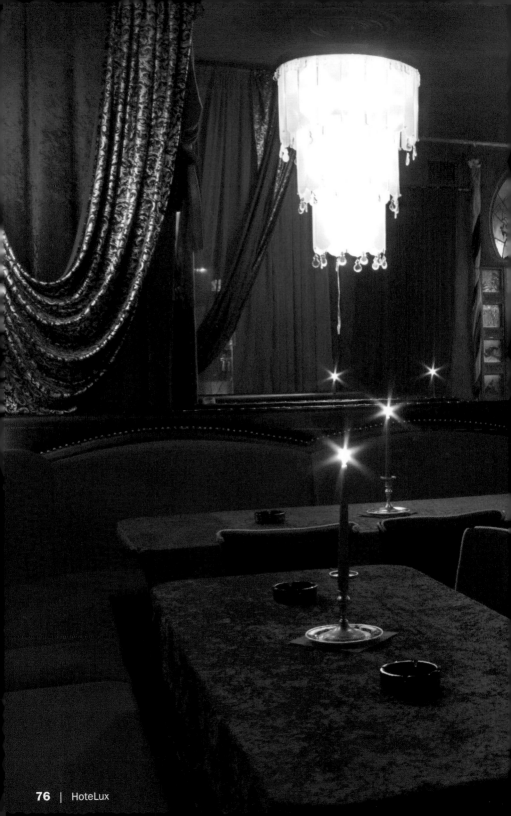

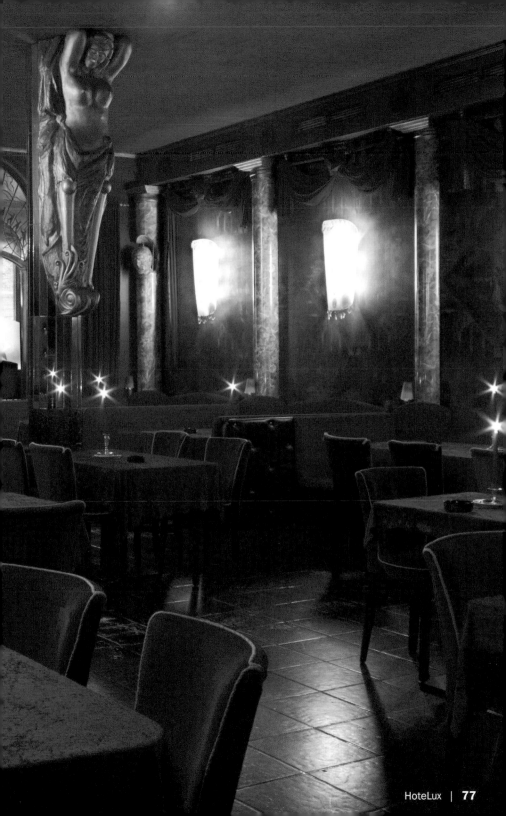

Lachs-Zander-Roulade

an Selleriesauce mit Safranreis

Salmon-Pike-Roulade on Celery Sauce with Saffron Rice

Roulade de saumon et de sandre, sauce de céleri et riz au safran

Rollo asado de salmón y lucio sobre salsa de apio y arroz con azafrán

Involtini di salmone e lucioperca in salsa di sedano con riso allo zafferano

6 Scheiben frischer Lachs, 10 x 15 x ½ cm
6 Streifen Zander, 10 cm
100 g frischer Spinat, geputzt
4 EL Pflanzenöl
2 EL Kürbiskerne
1 hartgekochtes Ei, gewürfelt
1 Knoblauchzehe, gehackt

1 Stange Sellerie, geputzt und gewürfelt
1 Zwiebel
120 ml Sahne
60 ml Weißwein
1 EL Estragon
Salz, Pfeffer, Zitronensaft
3 EL Butter

Sellerieblätter und Selleriemonde zur Dekoration
Safranreis als Beilage

Spinat fein hacken und mit den Kürbiskernen in 2 EL Öl anbraten, mit Ei und Knoblauch mischen und abschmecken. Die Lachsscheiben würzen, mit der Spinatmasse bestreichen, einen Streifen Zander auf jeden Lachs legen und einrollen. Jede Rolle in Alufolie wickeln und im Wasserbad bei niedriger Hitze ca. 35 Minuten pochieren. Sellerie und Zwiebel in 2 EL Öl anschwitzen, mit Sahne und Weißwein auffüllen und 10 Minuten leise köcheln lassen. Den Estragon dazugeben, pürieren und mit Salz, Pfeffer und Zitronensaft abschmecken. Die Butter unterrühren und warm stellen.
Die Lachsrollen aus der Alufolie lösen und diagonal halbieren. Auf jeden Teller 3 halbe Rollen setzen, Sauce ringsum gießen, dekorieren. Dazu Safranreis servieren.

6 slices fresh salmon, 4 x 6 x ⅕ in.
6 strips pike, 4 in.
3 ½ oz fresh spinach, cleaned
4 tbsp vegetable oil
2 tbsp pumpkin seeds
1 hard-boiled egg, diced
1 garlic clove, chopped

1 stick celery, cleaned and diced
1 onion
120 ml cream
60 ml white wine
1 tbsp tarragon
Salt, pepper, lemon juice
3 tbsp butter

Celery leaves and celery circles for decoration
Saffron rice as side dish

Finely chop the spinach and sautée with the pumpkin seeds in 2 tbsp oil, mix with the egg and garlic and season to taste. Season the salmon slices, coat with the spinach mixture, place a strip of pike on each piece of salmon and roll up. Wrap each roll in aluminum foil and poach in a bain-marie over low heat for approx. 35 minutes. Lightly brown the celery and onion in 2 tbsp oil, add the cream and white wine and gently simmer for 10 minutes. Add the tarragon, purée and season to taste with salt, pepper and lemon juice. Stir in the butter and keep warm.
Remove the salmon rolls from the foil and halve, diagonally. Place 3 half rolls on each plate, pouring the sauce around and decorate. Serve with saffron rice.

6 filets de saumon frais de 10 x 15 x ½ cm
6 lamelles de sandre de 10 cm
100 g d'épinards frais nettoyés
4 c. à soupe d'huile végétale
2 c. à soupe de graines de courge
1 œuf dur coupé en dés
1 gousse d'ail hachée

1 branche de céleri lavée et coupée en dés
1 oignon
120 ml de crème liquide
60 ml de vin blanc
1 c. à soupe d'estragon
Sel, poivre, jus de citron
3 c. à soupe de beurre

Feuilles de céleri et lunes de céleri en guise de garniture
Riz au safran comme accompagnement

Hacher menu les épinards et les faire revenir avec les graines de courge dans 2 c. à soupe d'huile, ajouter l'œuf et l'ail, puis mélanger. Aromatiser les filets de saumon, les badigeonner du mélange aux épinards, puis poser une lamelle de sandre sur chaque saumon et enrouler le tout. Envelopper chaque roulade dans une feuille d'aluminium et les pocher au bain-marie à feu doux pendant 35 minutes environ. Faire suer le céleri et l'oignon émincé dans 2 c. à soupe d'huile, ajouter la crème liquide et le vin blanc et laisser mijoter doucement 10 minutes. Ajouter l'estragon, réduire le mélange en purée, poivrer, saler et assaisonner de jus de citron. Incorporer le beurre et réserver au chaud.
Ôter les feuilles d'aluminium et couper les roulades en diagonale. Dresser 3 demi-roulades sur chaque assiette, verser la sauce autour et garnir. Servir le riz au safran.

6 lonchas de salmón fresco, 10 x 15 x ½ cm
6 lonchas de lucio, 10 cm
100 g de espinacas frescas, limpias
4 cucharadas de aceite vegetal
2 cucharadas de semillas de calabaza
1 huevo duro, en dados
1 diente de ajo, picado

1 rama de apio, limpia y en dados
1 cebolla
120 ml de nata
60 ml de vino blanco
1 cucharada de estragón
Sal, pimienta, zumo de limón
3 cucharadas de mantequilla

Hojas y medias lunas de apio para decorar
Arroz con azafrán como acompañamiento

Pique finamente las espinacas y sofríalas junto con las semillas de calabaza en 2 cucharadas de aceite, añada el huevo y el ajo y sazone. Condimente las lonchas de salmón, úntelas con la masa de las espinacas, ponga encima de cada loncha una tira de lucio y enrolle el salmón. Envuelva cada rollo en papel de aluminio y cuézalos en agua hirviendo a fuego lento durante aprox. 35 minutos. Rehogue el apio y la cebolla en 2 cucharadas de aceite, añada la nata y el vino blanco y deje que cueza a fuego lento durante 10 minutos. Incorpore el estragón, haga puré la mezcla y sazone con sal, pimienta y zumo de limón. Añada la mantequilla y reserve caliente. Quite el papel de aluminio de los rollos de salmón y córtelos en diagonal. Ponga en cada plato 3 mitades, vierta alrededor la salsa y decore. Acompañe con arroz con azafrán.

6 tranci di salmone fresco di 10 x 15 x ½ cm ciascuno
6 tranci di lucioperca di 10 cm ciascuno
100 g di spinaci freschi puliti
4 cucchiai di olio vegetale
2 cucchiai di semi di zucca
1 uovo sodo tagliato a dadini
1 spicchio d'aglio tritato

1 costa di sedano pulito e tagliato a dadini
1 cipolla
120 ml di panna
60 ml di vino bianco
1 cucchiaio di dragoncello
Sale, pepe, succo di limone
3 cucchiai di burro

Per la guarnizione: foglie e lunette di sedano
Per contorno: riso allo zafferano

Sminuzzare gli spinaci e rosolarli con i semi di zucca in 2 cucchiai di olio, mescolarli con l'uovo e l'aglio, assaggiare e regolare il condimento. Condire i tranci di salmone, spalmarli con il composto di spinaci, disporre un trancio di lucioperca su ogni pezzo di salmone e formare degli involtini. Avvolgere ogni involtino in foglio d'alluminio e farlo cuocere a bagnomaria a fiamma bassa per circa 35 minuti. Rosolare il sedano e la cipolla in 2 cucchiai di olio, ricoprire con la panna e il vino bianco e lasciar cuocere a fuoco lento per 10 minuti. Aggiungere il dragoncello, passare il composto con il passaverdura, assaggiare e condire con sale, pepe e succo di limone. Mantecare con il burro e tenere in caldo.
Estrarre gli involtini di salmone dal foglio d'alluminio e tagliarli diagonalmente a metà. Disporre su ogni piatto 3 mezzi involtini, versarvi intorno la salsa e guarnire. Servire con riso allo zafferano.

Kap am Südkai

Design: Cossmann de Bruyn | Chef: Steffen Kimmig
Owner: R.E.S. Rhein Event & Services GmbH

Agrippinawerft 30 | 50678 Köln | Rheinauhafen
Phone: +49 221 35 68 33 33
www.kapamsuedkai.de
Subway: Ubiering
Opening hours: Mon–Fri 8 am to midnight, Sat–Sun noon to midnight
Average price: € 19
Cuisine: European
Special features: Surprise menu, showkitchen

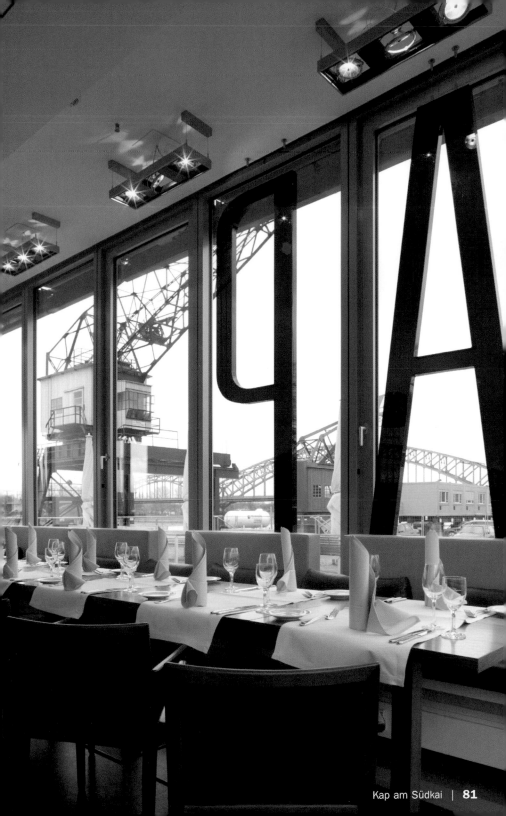

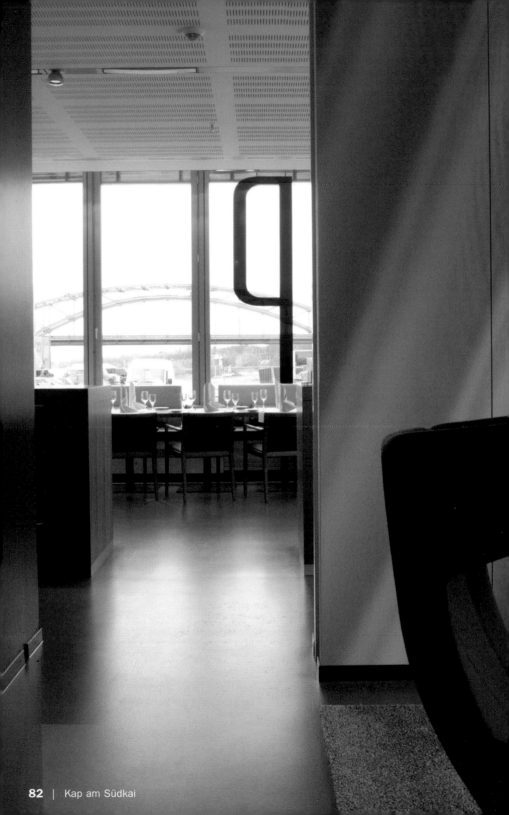

L. Fritz im HOPPER

Design: Rolf Kursawe | Chef: Christian Grindler
Owner: HOPPER GmbH

Dagobertstraße 32 | 50668 Köln | Altstadt-Nord
Phone: +49 221 1 66 05 00
www.hopper.de
Subway: Ebertplatz
Opening hours: Mon–Fri 7 am to open end, Sat–Sun 7 am to 11 am, 6 pm open end
Average price: € 17.50
Cuisine: Crossover
Special features: Joys apart from international photo art

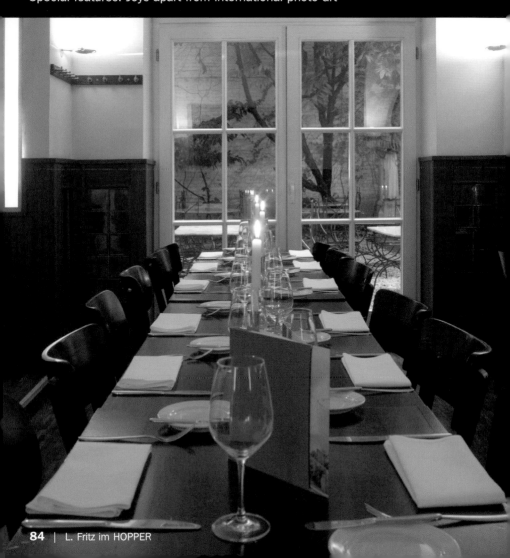

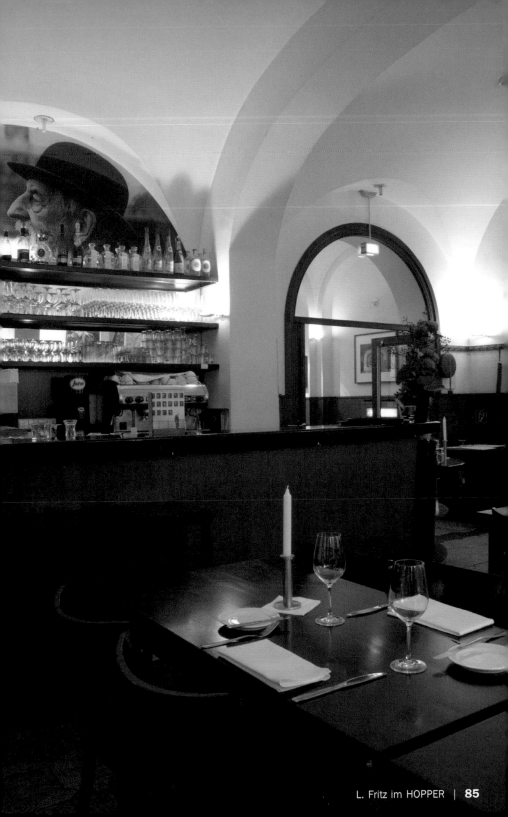

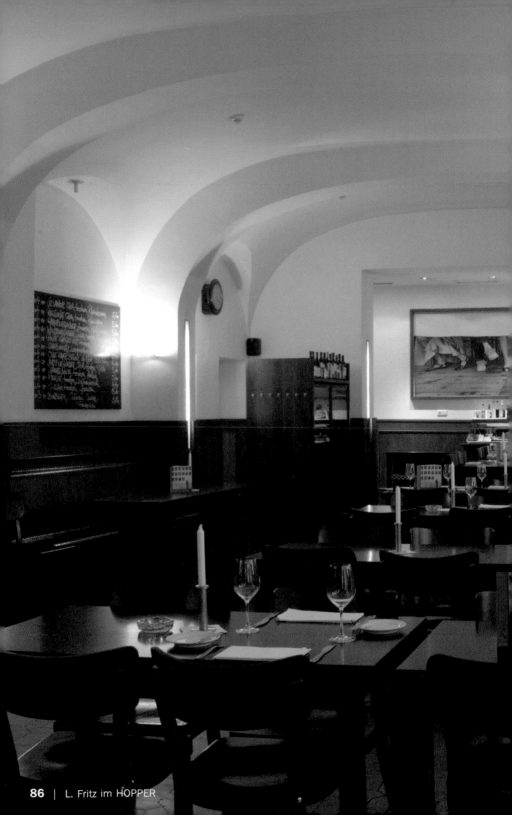

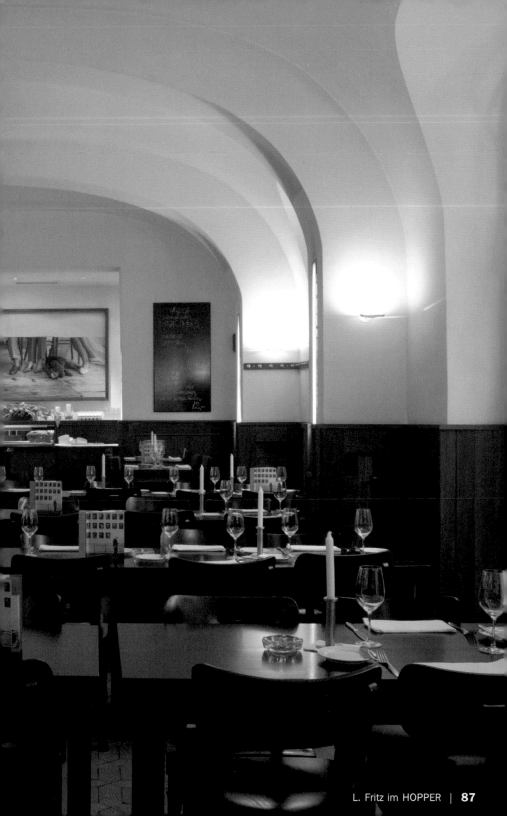

Maulbeers Restaurant

Design: k/h Büro für Innenarchitektur und Design
Chef: Jörg Stricker | Owner: InterContinental Köln

Pipinstraße 1 | 50667 Köln | Stadtmitte
Phone: +49 221 28 06 12 02
www.maulbeers.de
Subway: Heumarkt, Neumarkt
Opening hours: Tue–Sat 6 pm to 10:30 pm, Sun noon to 3 pm brunch
Average price: € 23
Cuisine: German, Mediterranean
Special features: Wine area and fire-place room, Gault Millau honor with 13 points

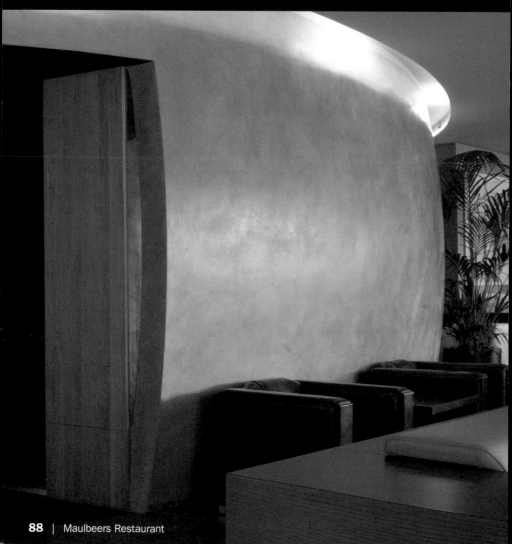

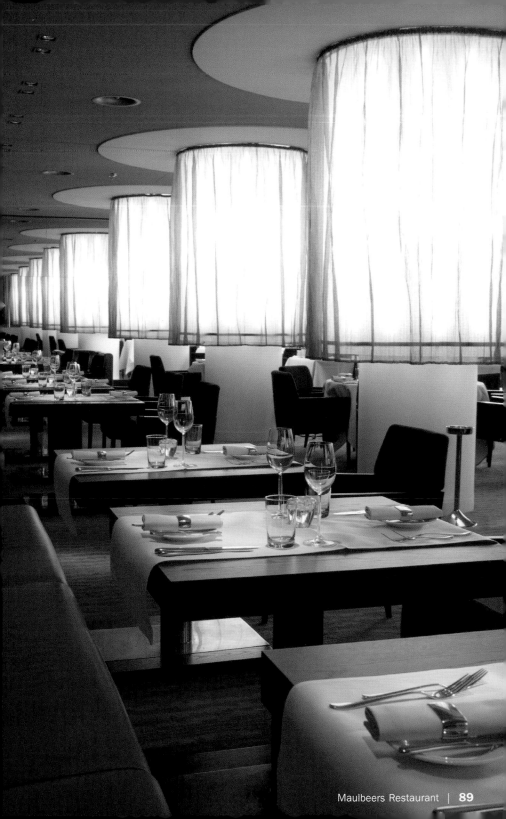

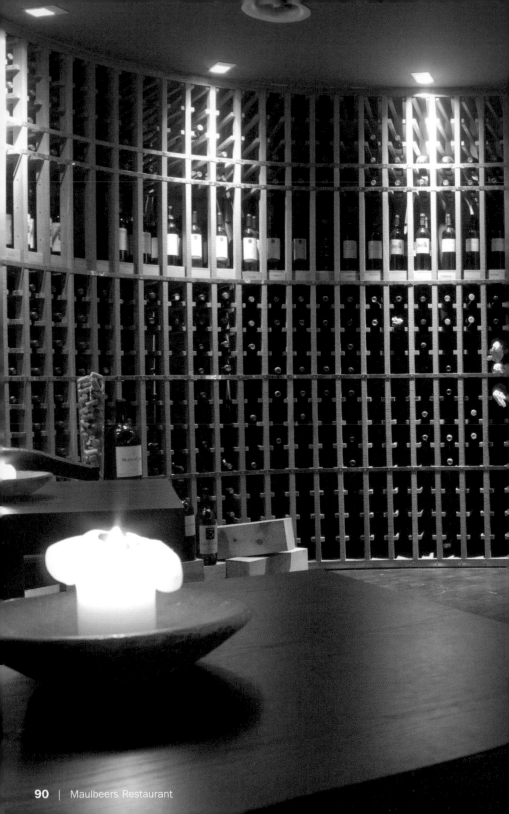

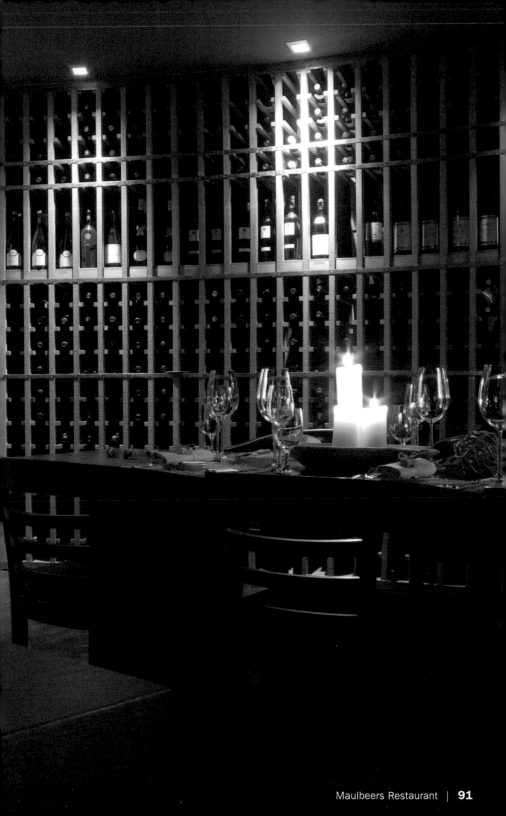

Bananen-Trilogie
an Kokosnuss

Banana Trilogy on Coconut

Trilogie de bananes à la noix de coco

Trilogía de plátanos con coco

Trilogia di banane con noce di cocco

10 Bananen
100 ml Läuterzucker (50 ml Wasser und 50 g
Zucker aufkochen und abkühlen lassen)
1 Eiweiß
1 Kochbanane
3 EL brauner Zucker
1 Kokosnuss
2 Platten Blätterteig, 10 x 20 cm
3 EL Kokosraspel
4 EL Jogurt
4 EL Mangopüree
8 Walnussmakronen
4 Minzspitzen

5 Bananen pürieren, mit dem Läuterzucker und
Eiweiß mischen und in einer Eismaschine frieren.

Die Kochbanane in 2 mm dünne Scheiben schneiden, mit 1 EL braunem Zucker bestreuen und bei 80 °C im Ofen trocknen. Die Kokosnuss aufbrechen, ebenfalls in dünne Scheiben schneiden und mit den Bananenscheiben trocknen. Aus jeder Blätterteigplatte zwei Kreise mit einem Durchmesser von 10 cm ausstechen und bei 200 °C ca. 6 Minuten backen. 4 Bananen halbieren und in Kokosraspeln wälzen. 1 Banane in Scheiben schneiden. Die 5 Bananen zusammen in 2 EL karamellisiertem, braunem Zucker schwenken. Jeweils 2 Bananenhälften in die Mitte des Tellers legen, 1 Blätterteigboden darauf legen und mit den karamellisierten Bananenscheiben bedecken. 1 Kugel Bananeneis darauf geben und mit Bananen- und Kokoschips garnieren. Mangopüree und Jogurt um das Dessert verteilen und mit Minze und Walnussmakronen dekorieren.

10 bananas
100 ml purified sugar (bring 50 ml water and
50 g sugar to the boil and allow to cool)
1 egg white
1 cooking banana
3 tbsp brown sugar
1 coconut
2 leaves filo dough, 4 x 8 in.
3 tbsp coconut flakes
4 tbsp yoghurt
4 tbsp mango purée
8 walnut macaroons
4 mint spears

Purée 5 bananas, mix with the purified sugar and
egg white and freeze in an ice cream maker.

Cut the cooking banana into 2 mm-thick slices, sprinkle with 1 tbsp brown sugar and dry in the oven at 170 °F. Break open the coconut, also cutting it into thin slices and dry with the banana pieces. Cut out 2 circles, à 4 in. diameter, from each sheet of filo dough and bake for approx. 6 minutes at 400 °F. Halve 4 bananas and roll in the coconut flakes. Chop 1 banana in slices. Toss the 5 bananas together in 2 tbsp of caramelized, brown sugar. Place 2 banana halves each in the middle of the plate, laying 1 sheet of filo pastry on top and covering with the caramelized banana chips. Top with 1 scoop of banana ice cream and garnish with bananas and coconut chips. Drizzle mango purée and yoghurt over the dessert and decorate with mint and walnut macaroons.

10 bananes
100 ml de sirop (porter à ébullition 50 ml d'eau et 50 g de sucre, puis laisser refroidir)
1 blanc d'œuf
1 banane à cuire
3 c. à soupe de sucre brun
1 noix de coco
2 rectangles de pâte feuilletée de 10 x 20 cm
3 c. à soupe de noix de coco râpée
4 c. à soupe de yaourt
4 c. à soupe de purée de mangue
8 macarons aux noix
4 brins de menthe

Réduire 5 bananes en purée, ajouter le sirop et le blanc d'œuf puis mélanger et congeler dans une sorbetière.

Couper la banane à cuire en rondelles de 2 mm d'épaisseur, saupoudrer 1 c. à soupe de sucre brun dessus et laisser sécher au four à 80 °C. Ouvrir la noix de coco, la couper aussi en fines tranches et les faire sécher avec les rondelles de banane.
Sur chaque pâte feuilletée, tracer 2 cercles de 10 cm de diamètre et les faire cuire au four 6 minutes environ à 200 °C.
Couper 4 bananes en deux et les rouler dans la noix de coco râpée. Couper 1 banane en rondelles. Saisir légèrement les 5 bananes dans 2 c. à soupe de sucre brun caramélisé. Dresser 2 moitiés de banane au milieu de chaque assiette, les couvrir d'une rondelle de pâte et ajouter dessus les rondelles de banane caramélisées. Poser 1 boule de glace à la banane par-dessus et garnir de chips de banane et de coco. Répartir la purée de mangue et le yaourt autour du dessert, puis garnir de menthe et de macarons.

10 plátanos
100 ml de azúcar purificado (hervir 50 ml de agua y 50 g de azúcar y dejar enfriar)
1 clara de huevo
1 plátano para cocinar
3 cucharadas de azúcar moreno
1 coco
2 láminas de pasta de hojaldre, 10 x 20 cm
3 cucharadas de coco rallado
4 cucharadas de yogur
4 cucharadas de puré de mango
8 mostachones de nueces
4 puntas de menta

Haga puré 5 plátanos, mézclelos con el azúcar refinado y la clara y congele la mezcla en una heladera.

Corte el plátano para cocinar en rodajas de 2 mm, esparza por encima 1 cucharada de azúcar moreno y déjelas secar en el horno a 80 °C. Abra el coco, córtelo también en finas rodajas y déjelas secar junto con las de plátano.
Corte 2 círculos en cada lámina de pasta de hojaldre de 10 cm de diámetro y hornéelos durante aprox. 6 minutos a 200 °C.
Corte 4 plátanos en mitades y rebócelas en la ralladura de coco. Corte 1 plátano en rodajas. Saltee los 5 plátanos juntos en 2 cucharadas de azúcar moreno caramelizado. Ponga en el centro de cada plato 2 mitades de plátano, coloque encima 1 círculo de hojaldre y cubra con las rodajas de plátano caramelizadas. Ponga encima 1 bola de helado de plátano y adorne con laminillas de plátano y coco. Reparta el puré de mango y el yogur alrededor del postre y decore con la menta y los mostachones.

10 banane
100 ml di zucchero cotto (cuocere 50 ml di acqua e 50 g di zucchero e lasciar raffreddare)
1 albume d'uovo
1 banana da cuocere
3 cucchiai di zucchero bruno
1 noce di cocco
2 fogli di pasta sfoglia di 10 x 20 cm
3 cucchiai di cocco in scaglie
4 cucchiai di yogurt
4 cucchiai di purea di mango
8 amaretti di noci
4 punte di menta

Passare al passaverdura 5 banane, mescolarle con lo zucchero cotto e l'albume d'uovo e congelare il tutto in una macchina per fare il ghiaccio.

Tagliare la banana da cuocere a fettine dello spessore di 2 mm, cospargerle con 1 cucchiaio di zucchero bruno e lasciarla asciugare in forno a 80 °C. Aprire la noce di cocco, tagliarla a fette sottili e metterla ad asciugare insieme alle fettine di banana.
Ricavare da ogni foglio di pasta sfoglia 2 cerchi del diametro di 10 cm e cuocerli in forno a 200 °C per circa 6 minuti.
Dimezzare 4 banane e passarle nelle scaglie di cocco. Affettare 1 banana. Saltare le 5 banane in 2 cucchiai di zucchero bruno caramellizzato. Disporre 2 mezze banane al centro di ogni piatto, appoggiarvi 1 foglio di pasta sfoglia e ricoprire il tutto con le fettine di banana caramellizzate. Porvi sopra 1 pallina di gelato alla banana e guarnire con pezzetti di banana e di cocco. Disporre la purea di mango e lo yogurt intorno al dessert e guarnire con la menta e gli amaretti di noci.

Mongo'S Restaurant

Design: Rüdiger Dunkel | Chef: Andreas Weidner
Owners: S. Soukas, C.Blech, A. Kh. Shirazi

Ottoplatz 1 | 50679 Köln | Deutz
Phone: +49 221 9 89 38 10
www.mongos.de
Subway: Köln-Deutz
Opening hours: Mon–Sun noon to midnight
Average price: € 19.90
Cuisine: Mongolian Barbeque
Special features: Showcooking

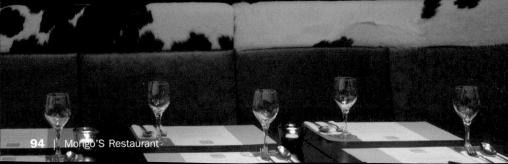

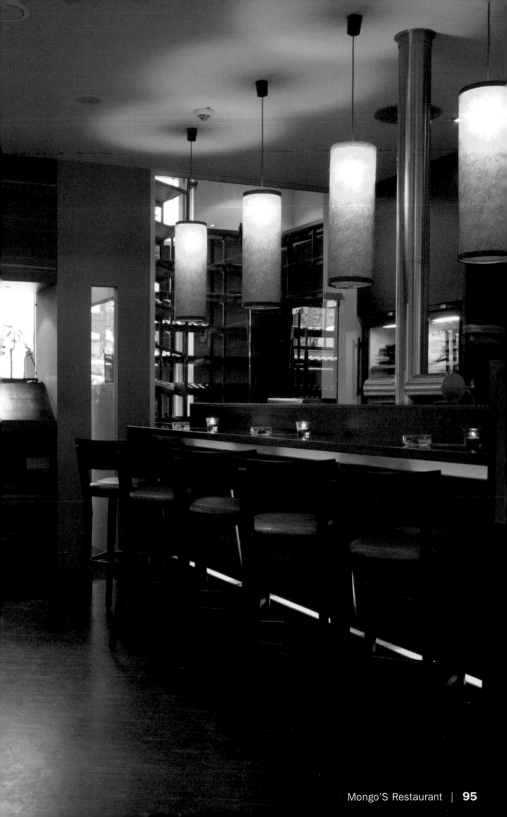

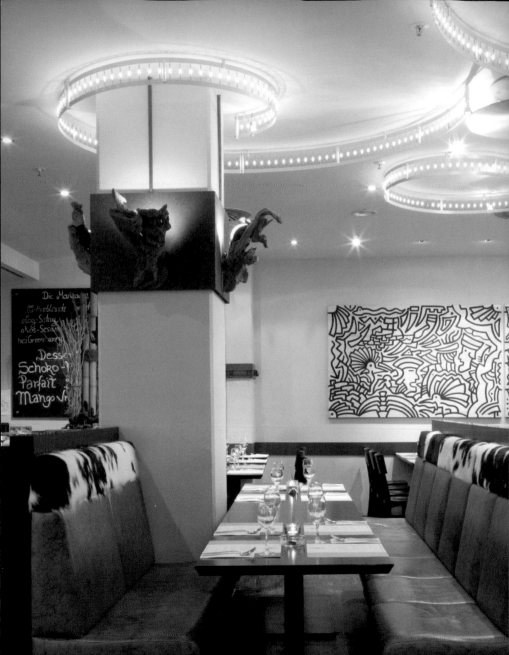

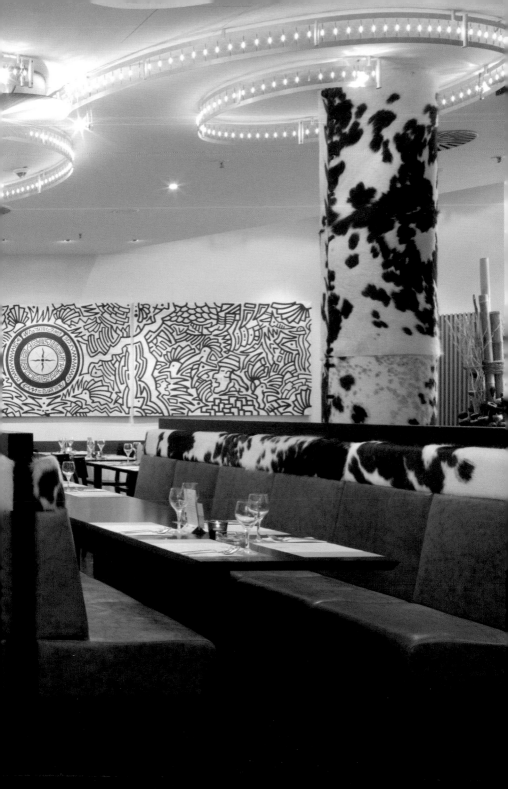

Kardamom Crème Brûlée

mit Granatapfel-Chutney

Cardamom Crème Brûlée with
Pomegranate Chutney

Crème brûlée à la cardamome avec
chutney de grenade

Crème brûlée de cardamomo con *chutney*
de granada

Crème brulè al cardamomo con chutney
di melagrane

250 ml Sahne
150 ml Milch
3 EL Zucker
1 TL Kardamom, gemahlen
4 Eigelb

200 g brauner Zucker
1 Schalotte, gewürfelt
2 Granatäpfel
100 ml Weißweinessig
1 Prise Salz
1 Prise Kardamom

Brauner Zucker zum Gratinieren
Frische Früchte zum Dekorieren

Sahne, Milch, Zucker, Kardamom und Eigelbe miteinander verrühren und über Nacht ziehen lassen. Die Mischung nochmals umrühren und in 4 Förmchen füllen. Den Ofen auf 140 °C vorheizen, die Förmchen auf ein tiefes Blech geben und in den Ofen stellen. Kochendes Wasser bis zur halben Höhe der Förmchen auf das Blech gießen und die Crème Brûlée 40 Minuten pochieren. Aus dem Ofen nehmen und bei Zimmertemperatur abkühlen lassen.
Den braunen Zucker in einem kleinen Topf karamellisieren lassen, die Schalottenwürfel dazugeben und mit dem Saft eines Granatapfels ablöschen. Mit Essig auffüllen, mit Salz und Kardamom würzen und 10 Minuten köcheln lassen. In der Zwischenzeit die Kerne des zweiten Granatapfels auslosen und in den Topf geben. Vom Herd nehmen und beiseite stellen.
Zum Servieren die Crème Brûlée mit etwas braunem Zucker bestreuen und mit einem Bunsenbrenner gratinieren. Mit Minze und frischen Früchten garnieren und mit dem Granatapfel-Chutney auf Tellern anrichten.

250 ml cream
150 ml milk
3 tbsp sugar
1 tsp cardamom, ground
4 egg yolks

7 oz brown sugar
1 shallot, diced
2 pomegranates
100 ml white wine vinegar
1 pinch salt
1 pinch cardamom

Brown sugar for glazing
Fresh fruits for decoration

Mix the cream, milk, sugar, cardamom and egg yolks together and allow to rest overnight. Stir the mixture again and spoon into 4 small ramequin dishes. Pre-heat the oven at 280 °F, place the dishes on a deep tray and set in the oven. Pour boiling water onto the tray half way up the dishes and poach the crème brûlée for 40 minutes. Remove from the oven and allow to cool at room temperature.
Caramelize the brown sugar in a small saucepan, add the diced shallot and pour in the juice of a pomegranate. Add the vinegar, season with salt and cardamom and allow to simmer for 10 minutes. Meanwhile, remove the seeds from the second pomegranate and place in a saucepan. Remove from the oven and set aside.
To serve, sprinkle the crème brûlée with a little brown sugar and glaze with a Bunsen burner. Garnish with mint and fresh fruits and arrange on plates with the pomegranate chutney.

250 ml de crème liquide
150 ml de lait
3 c. à soupe de sucre
1 c. à café de cardamome moulue
4 jaunes d'œuf

200 g de sucre brun
1 échalote coupée en dés
2 grenades
100 ml vinaigre blanc
1 pincée de sel
1 pincée de cardamome

Du sucre brun pour gratiner
Des fruits frais pour la garniture

Mélanger la crème liquide, le lait, le sucre, la cardamome et les jaunes d'œuf et laisser reposer toute une nuit. Remuer de nouveau le mélange et en remplir quatre petits moules. Préchauffer le four à 140 °C, poser les moules sur une plaque creuse et enfourner. Verser de l'eau bouillante sur la plaque jusqu'à mi-hauteur des moules et pocher la crème brûlée pendant 40 minutes. Sortir du four et laisser refroidir à température ambiante.

Caraméliser le sucre brun dans une petite casserole, ajouter l'échalote et déglacer avec du jus d'une grenade. Verser le vinaigre, saler, assaisonner de cardamome et laisser mijoter 10 minutes. Pendant ce temps, égrainer la seconde grenade et la verser ensuite dans la casserole. Retirer du feu et réserver.

Pour servir la crème brûlée, la saupoudrer de sucre brun et la faire gratiner avec un bec Bunsen. La garnir de menthe et de fruits frais et la dresser sur les assiettes avec le chutney de grenade.

250 ml de nata
150 ml de leche
3 cucharadas de azúcar
1 cucharadita de cardamomo molido
4 yemas de huevo

200 g de azúcar moreno
1 chalote, en dados
2 granadas
100 ml de vinagre de vino blanco
1 pizca de sal
1 pizca de cardamomo

Azúcar moreno para gratinar
Frutos frescos para gratinar

Mezcle la nata con la leche, el azúcar, el cardamomo y las yemas y deje reposar la mezcla durante la noche. Remueva otra vez la mezcla y repártala en cuatro moldes pequeños. Precaliente el horno a 140 °C, coloque los moldes en una bandeja profunda e introdúzcalos en el horno. Vierta agua hirviendo en la bandeja hasta llegar a media altura de los moldes y escalfe la crème brûlée durante 40 minutos. Saque los moldes del horno y deje que se enfríen hasta alcanzar la temperatura ambiente.

Caramelice el azúcar moreno en una pequeña cazuela, incorpore los dados de chalote y vierta dentro el zumo de una granada. Añada el vinagre, sazone con la sal y el cardamomo y deje que hierva a fuego lento durante 10 minutos. En ese tiempo desgrane la segunda granada e incorpore los granos a la cazuela. Retírela del fuego y reserve.

Para servir la crème brûlée esparza por encima un poco de azúcar moreno y gratínela con un soplete de cocina. Decórela con menta y frutos frescos y reparta alrededor el chutney de granada.

250 ml di panna
150 ml di latte
3 cucchiai di zucchero
1 cucchiaino di cardamomo macinato
4 tuorli d'uovo

200 g di zucchero bruno
1 scalogno tagliato a dadini
2 melagrane
100 ml di aceto di vino bianco
1 presa di sale
1 presa di cardamomo

Zucchero bruno per gratinare
Per la guarnizione: frutta fresca

Mescolare la panna, il latte, lo zucchero, il cardamomo ed i tuorli d'uovo e lasciarli riposare per una notte. Mescolare nuovamente il composto e versarlo in quattro stampini. Riscaldare il forno a 140 °C, disporre gli stampini su una leccarda alta e metterli in forno. Versare dell'acqua bollente nella leccarda fino a metà altezza degli stampini e cuocere la crème brulè a bagnomaria per 40 minuti, quindi estrarla dal forno e lasciarla raffreddare a temperatura ambiente.

Caramellizzare in un pentolino lo zucchero bruno, unirvi lo scalogno a dadini e bagnare con il succo di una melagrana. Ricoprire con l'aceto, salare, aggiungere il cardamomo e cuocere a fiamma bassa per 10 minuti. Nel frattempo, private dei semi l'altra melagrana ed unire i semi al composto nella pentola. Togliere dal fuoco e mettere da parte il tutto.

Al momento di servire cospargere la crème brulè di zucchero bruno e gratinarla con un becco di Bunsen. Guarnirla con la menta e la frutta fresca e disporla sui piatti con il chutney alla melagrana.

Nyam Nyam

Design: Bettina Thielen, Edyth Kozikowski | Chef: Sith
Owners: Ralf Krüger, Edyth Kozikowski, Burkhard Kuhr

Ehrenstraße 25–27 | 50672 Köln | Stadtmitte
Phone: +49 221 3 55 62 69
www.nyam-nyam.de
Subway: Neumarkt
Opening hours: Mon–Sat 11:30 am to 9 pm, Sun closed
Average price: € 4
Cuisine: Thai
Special features: Feel-good-food

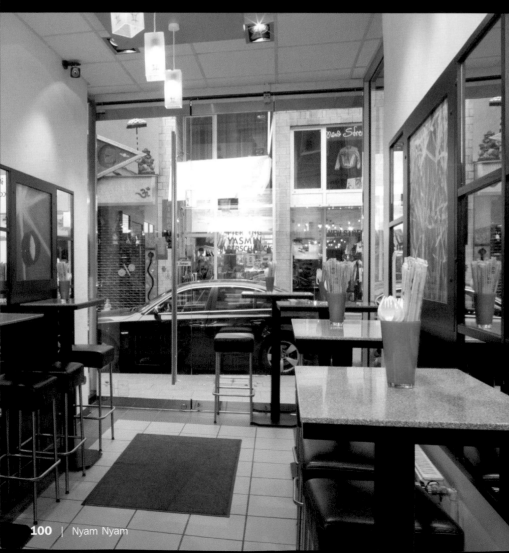

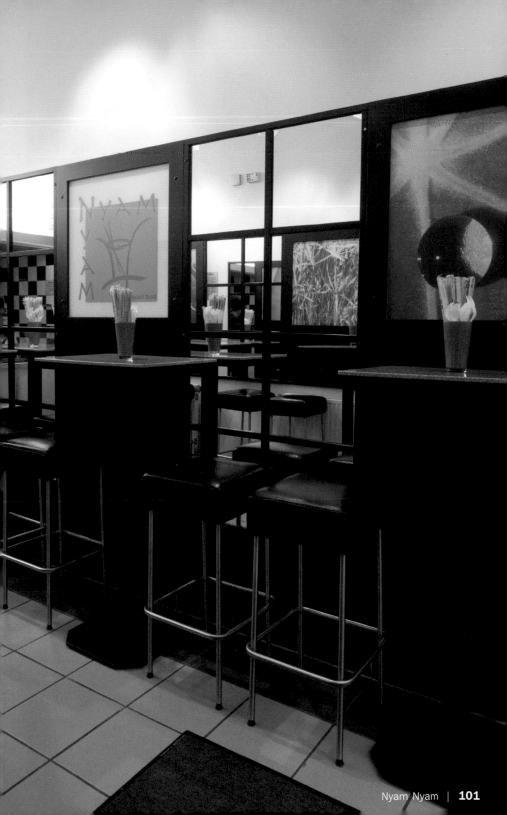

Osman

Design: Marc Newson | Chef: Dario Cammarata
Owner: Osman Yalcin

Im Mediapark 7 | 50670 Köln | Stadtmitte
Phone: +49 221 4 71 25 82
www.osman-cologne.de
Subway: Christofstraße, Mediapark
Opening hours: Mon–Fri noon to 3 pm, 6 pm to midnight, Sat–Sun only for events
Average price: € 17.50
Cuisine: Mediterranean

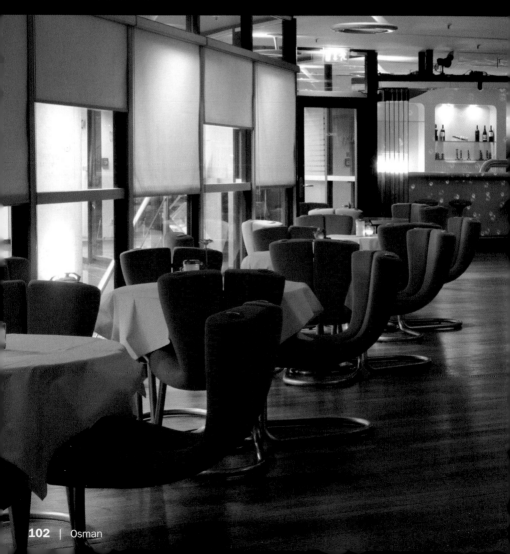

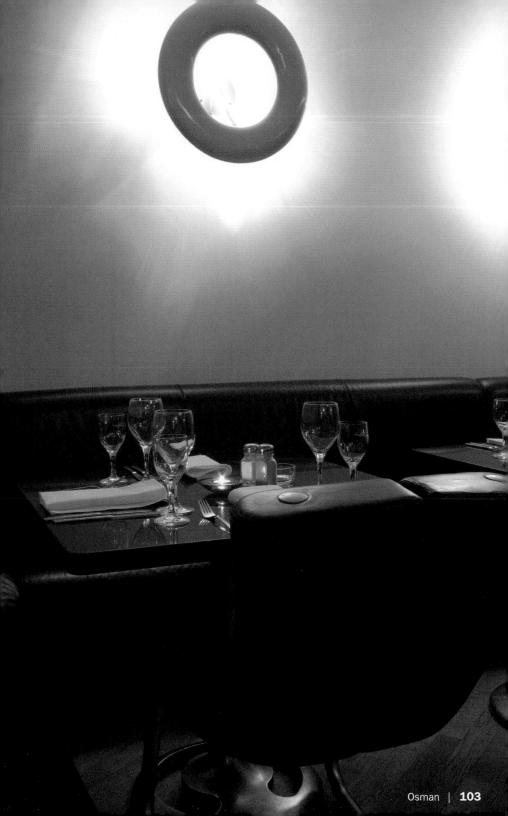

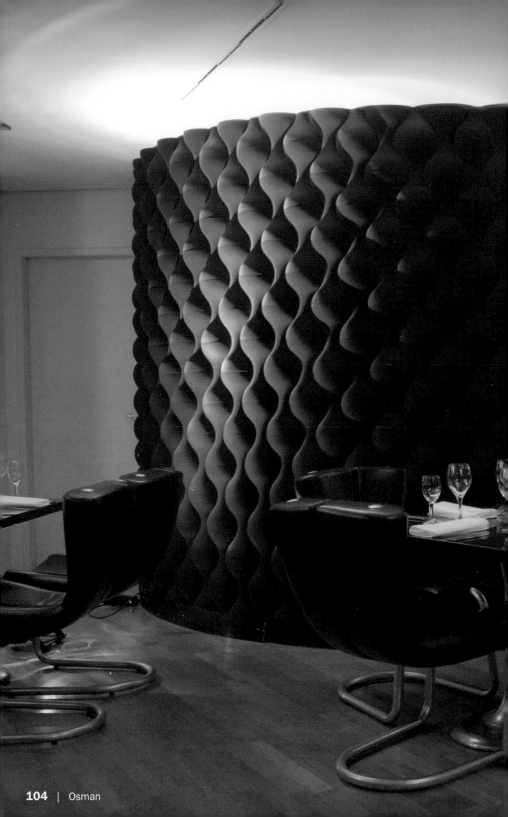

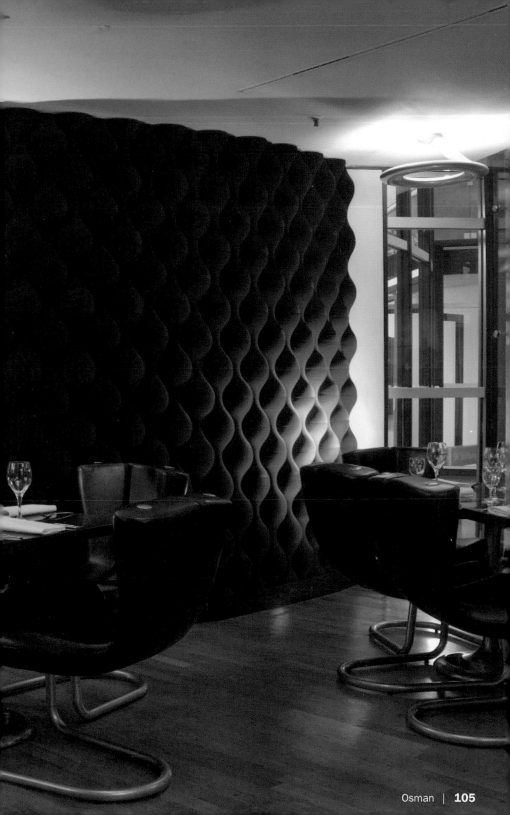

paparazzi

lounge bar & restaurant

Design: k/h Büro für Innenarchitektur und Design, Henri Chebanne
Chef: Giuseppe Bongiovi | Owner: Radisson SAS Hotel Köln

Messe Kreisel 3 | 50679 Köln | Deutz
Phone: +49 221 2 77 20 34 66
www.paparazzilounge.de
Subway: Köln Messe, Osthallen
Opening hours: Mon–Fri noon to 3 pm, 6 pm to 11 pm, Sat–Sun 6 pm to 11 pm
Average price: € 16
Cuisine: Italian

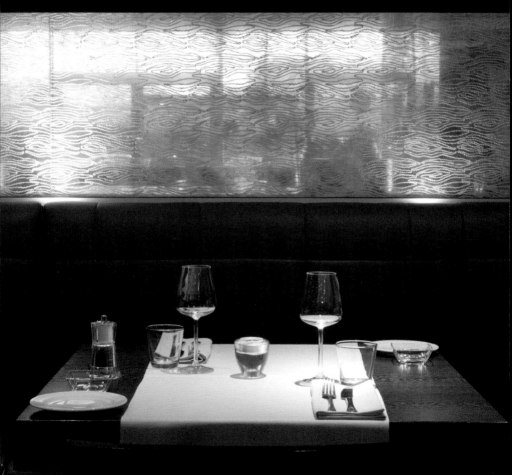

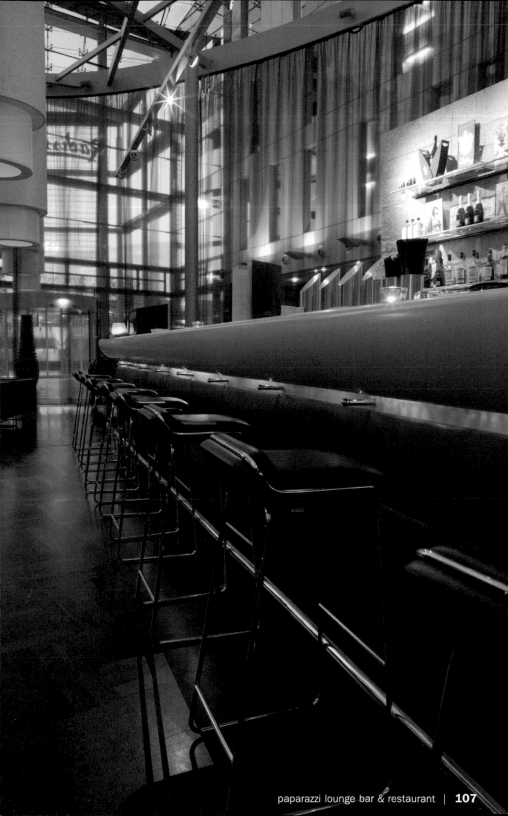

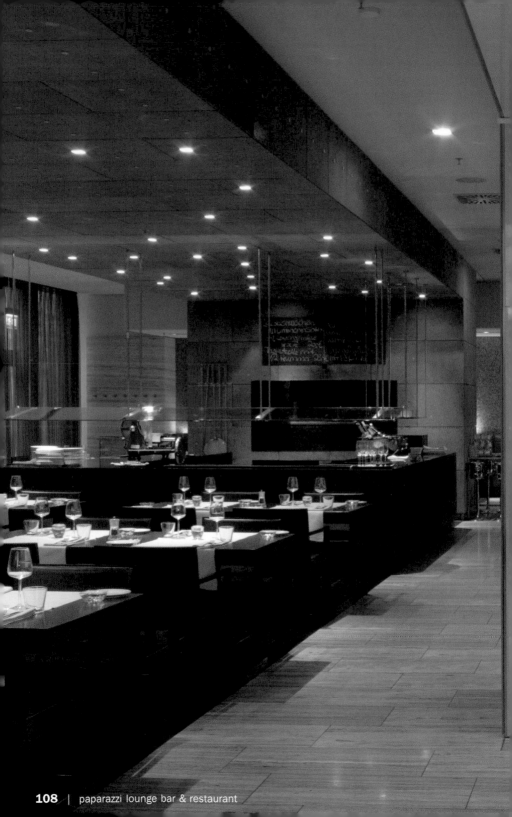

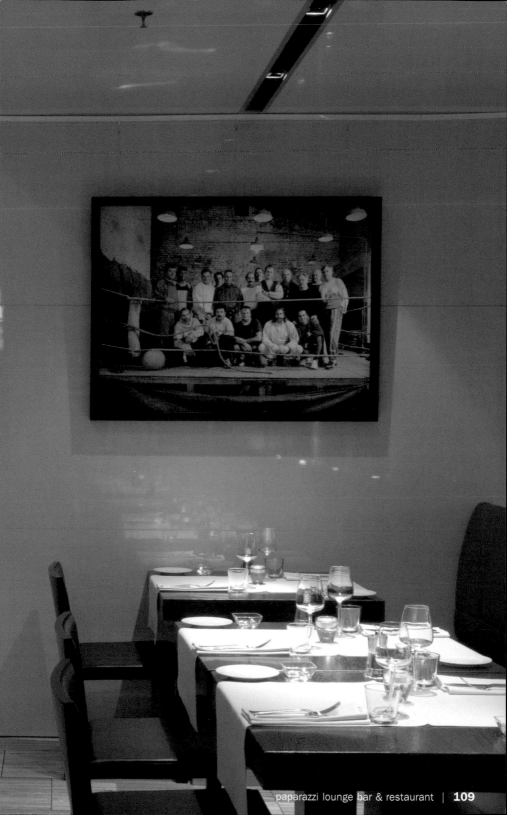

Saltimbocca vom Seeteufel

auf Limonenrisotto

Saltimbocca of Monkfish on Lime Risotto

Saltimbocca de lotte sur lit de risotto au citron vert

Saltimbocca de rape sobre un lecho de *risotto* de limón

Saltimbocca di rana pescatrice con risotto al limone

1 küchenfertiges Seeteufelfilet, à 750 g
Salz, Pfeffer
12 Scheiben Parmaschinken
12 Salbeiblätter

2 Schalotten, gehackt
3 EL Olivenöl
200 g Risottoreis
400 ml Brühe
2 Limetten
3 EL Parmesan, gerieben
3 EL Butter
Lauchstreifen zur Dekoration

Das Seeteufelfilet würzen, mit dem Salbei belegen, mit Parmaschinken umwickeln und in Alufolie einschlagen. Von allen Seiten anbraten und bei 150 °C 10 Minuten im Ofen garen.

Für das Risotto den Reis in Olivenöl anschwitzen, nach und nach mit Brühe ablöschen und weich kochen lassen. Mit Limettenschale und -saft, Parmesan und Butter abschmecken und evtl. würzen.

Zum Servieren das Filet in vier Stücke schneiden, jedes noch einmal schräg halbieren und auf dem Risotto anrichten. Mit frischen Lauchstreifen garnieren.

1 pre-prepared monkfish fillet, à 1 ½ lb
Salt, pepper
12 slices Parma ham
12 sage leaves

2 shallots, chopped
3 tbsp olive oil
7 oz risotto rice
400 ml stock
2 limes
3 tbsp Parmesan, grated
3 tbsp butter
Leek strips, for decoration

Season the monkfish fillet, cover with the sage, wrap in Parma ham and coat in aluminum foil. Sautée on all sides and bake in the oven for 10 minutes at 300 °F.

For the risotto, sautée the rice in olive oil, gradually add the stock and simmer until soft. Season to taste with the lime juice and rind, Parmesan and butter, adding extra seasoning if required.

To serve, carve the fillet into four pieces, diagonally halving each one again; and arrange on the risotto. Garnish with fresh strips of leek.

1 filet de lotte de 750 g
Sel, poivre
12 tranches de jambon de Parme
12 feuilles de sauge

2 échalotes hachées
3 c. à soupe d'huile d'olive
200 g de risotto
400 ml de bouillon
2 citrons verts
3 c. à soupe de parmesan râpé
3 c. à soupe de beurre
Lamelles de poireau pour la garniture

Assaisonner le filet de lotte, le garnir de sauge, l'envelopper dans le jambon de Parme, puis l'emballer dans une feuille d'aluminium. Le poêler sur toutes ses faces, puis le laisser cuire 10 minutes au four à 150 °C.

Pour le risotto, faire blondir le riz dans l'huile d'olive, puis mouiller progressivement de bouillon et poursuivre la cuisson en le laissant ramollir. Assaisonner de zeste et de jus de citron vert, de parmesan et de beurre, et épicer éventuellement.

Couper le filet de lotte en quatre morceaux, puis de nouveau en biais et disposer sur le risotto. Garnir de lamelles de poireau et servir.

1 filete de rape listo para cocinar, de 750 g
Sal, pimienta
12 lonchas de jamón curado
12 hojas de salvia

2 chalotes, picados
3 cucharadas de aceite de oliva
200 g de arroz para *risotto*
400 ml de caldo
2 limas
3 cucharadas de queso parmesano, rallado
3 cucharadas de mantequilla
Tiras de puerro, para decorar

Sazone el filete de rape, cúbralo con las hojas de salvia, enróllelo con el jamón y envuélvalo en papel de aluminio. Fría el paquetito por todos los lados y después áselo en el horno durante 10 minutos a 150 °C.

Para preparar el risotto, rehogue el arroz en aceite de oliva, vierta poco a poco el caldo y deje que cueza a fuego lento. Añada la piel de las limas, el zumo, el queso parmesano y la mantequilla y sazone si fuera necesario.

Para servir corte el filete en cuatro trozos, corte cada porción diagonalmente por la mitad y colóquelas encima del *risotto*. Decore con tiras de puerro fresco.

1 filetto di rana pescatrice di 750 g pronto per la cottura
Sale, pepe
12 fette di prosciutto di Parma
12 foglie di salvia

2 scalogni tritati
3 cucchiai di olio d'oliva
200 g di riso per risotti
400 ml di brodo
2 limette
3 cucchiai di parmigiano grattugiato
3 cucchiai di burro
Per la guarnizione: strisce di porro

Condire il filetto di rana pescatrice, ricoprirlo con la salvia, avvolgerlo nel prosciutto e quindi in un foglio d'alluminio. Rosolarlo da tutti i lati e cuocere in forno a 150 °C per 10 minuti.

Per il risotto: abbrustolire il riso in olio di oliva, quindi bagnarlo un po' alla volta con il brodo finché non sia cotto. Assaggiare e condire con buccia e succo di limetta, parmigiano e burro.

Al momento di servire, tagliare il filetto in quattro, dimezzare diagonalmente ogni pezzo e disporre il pesce sul risotto. Guarnire con strisce di porro fresco.

Poisson

Design: Gaston Muller | Chef: Raimund Musar
Owners: I. Muller, Lars Hundhausen

Wolfsstraße 6–14 | 50667 Köln | Stadtmitte
Phone: + 49 221 2 72 49 48
www.poisson.de
Subway: Neumarkt
Opening hours: Mon–Sun noon to 11 pm
Average price: € 23
Cuisine: French
Special features: Fish shop, Plateau Royal

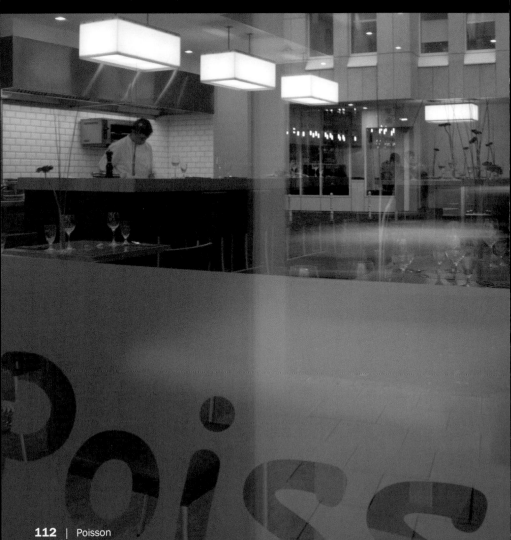

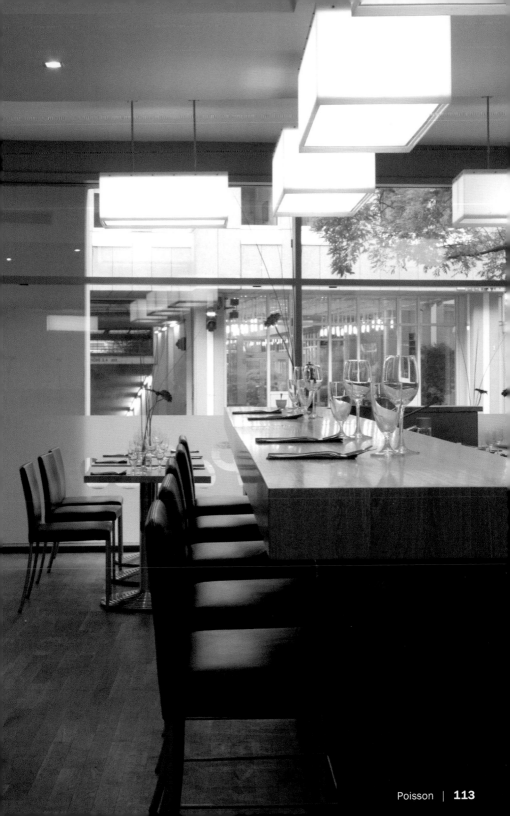

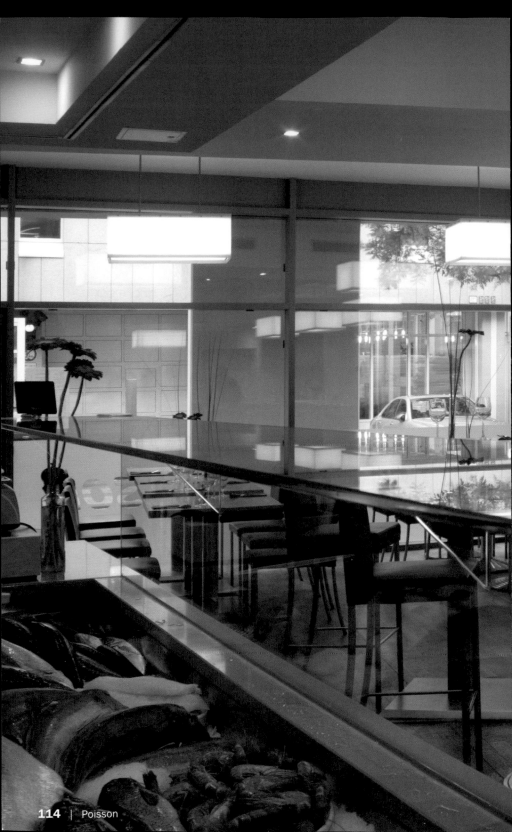

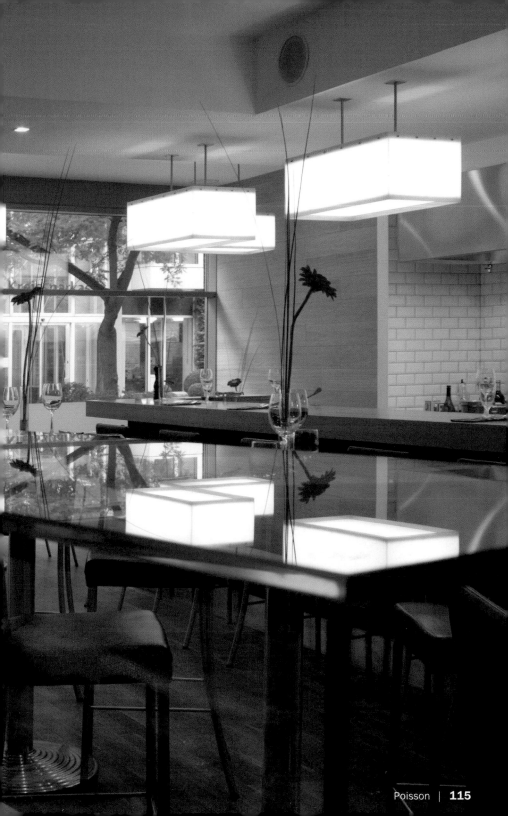

Rheinterrassen Köln

Design: Gunther Spitzley | Chef: Julian Doncaster
Owner: Rhein Connection GmbH

Rheinparkweg 1 | 50679 Köln | Deutz
Phone: + 49 221 8 80 95 31
www.rhein-terrassen.de
Subway: Tanzbrunnen
Opening hours: Mon–Sat 6 pm to 1 am, Sun noon to open end
Average price: € 15
Cuisine: Crossover
Special features: Monthly Firecraecker Party, Sundays and holidays noon to 5 pm
chill out breakfast

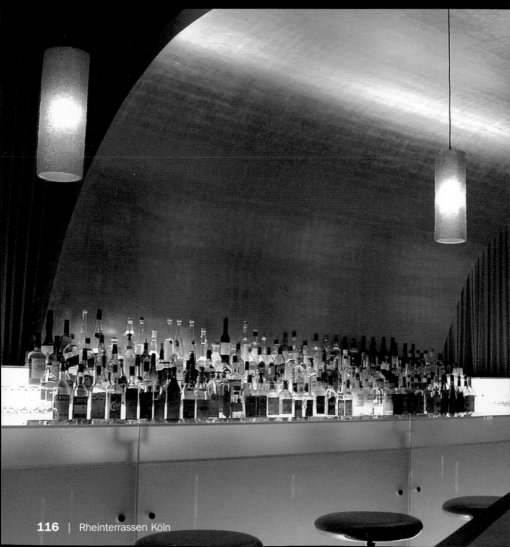

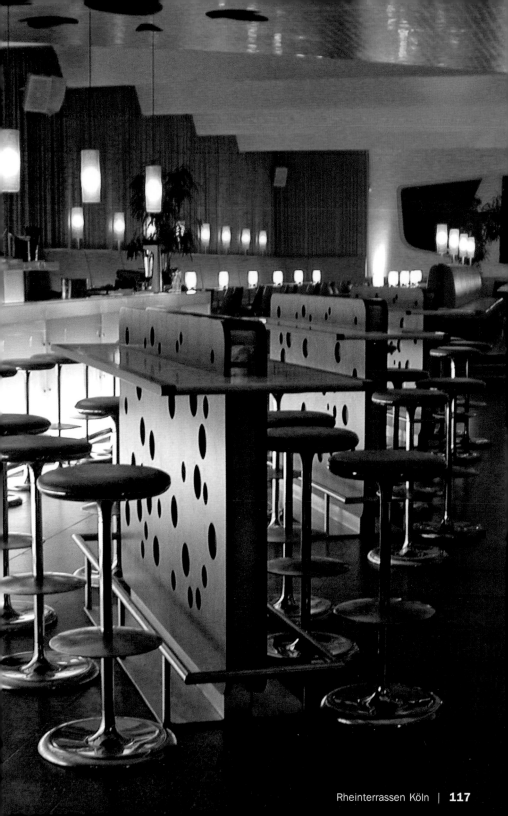

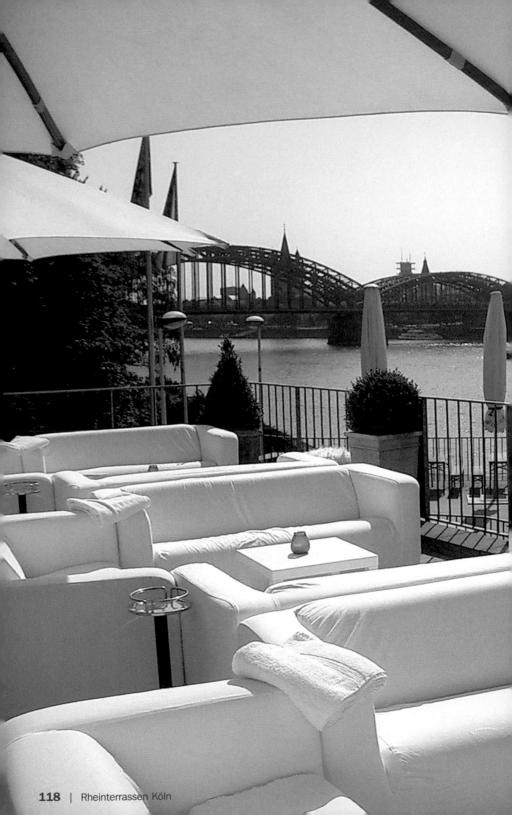

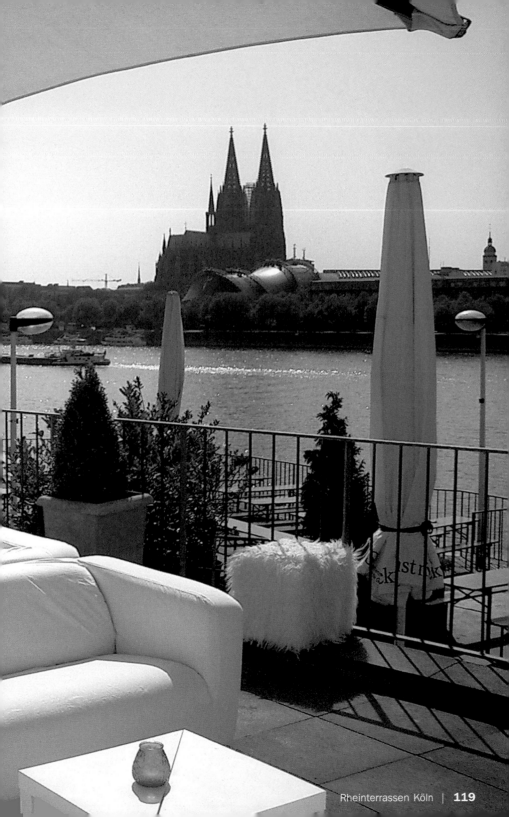

Rheinterrassen Köln | **119**

Sterns Restaurant

Design: Klaus Müller | Chef: Stephan Jaud, Stefan Rittger
Owners: Claudia Stern, Michael Stern, Stephan Jaud

Hahnenstraße 37 | 50667 Köln | Stadtmitte
Phone: +49 221 9 23 66 44
www.sterns.tv
Subway: Rudolfplatz, Neumarkt
Opening hours: Mon–Sat noon to 1 am, Sun closed
Average price: € 18
Cuisine: Crossover
Special features: Young design, event salon for up to 300 guests

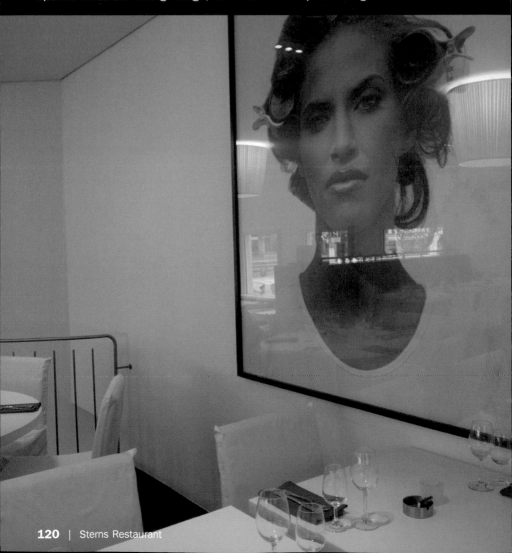

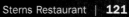

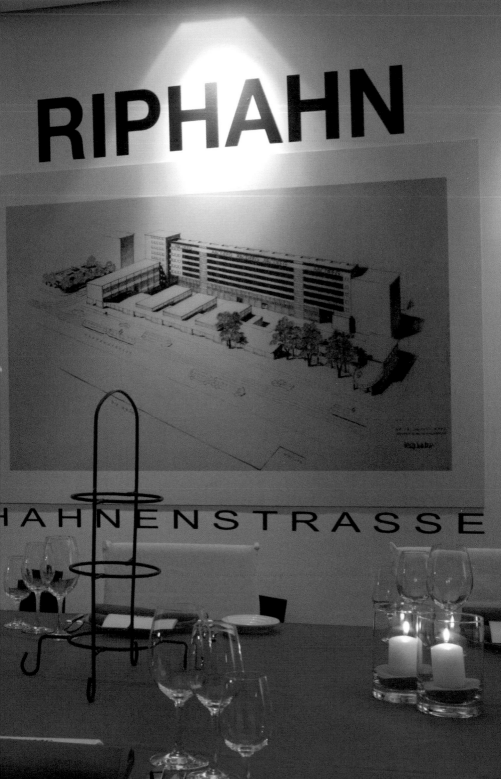

taku

Design: Reiner Jensen | Chef: Sven Feldmann
Owner: Excelsior Hotel Ernst

Trankgasse 1–5 (Domplatz) | 50667 Köln | Stadtmitte
Phone: +49 221 2 70 39 10
www.excelsior-hotel-ernst.de
Subway: Dom/Hauptbahnhof
Opening hours: Mon–Sun noon to 3 pm, 6 pm to midnight
Average price: € 24
Cuisine: Asian
Special features: The restaurant can be booked exclusively

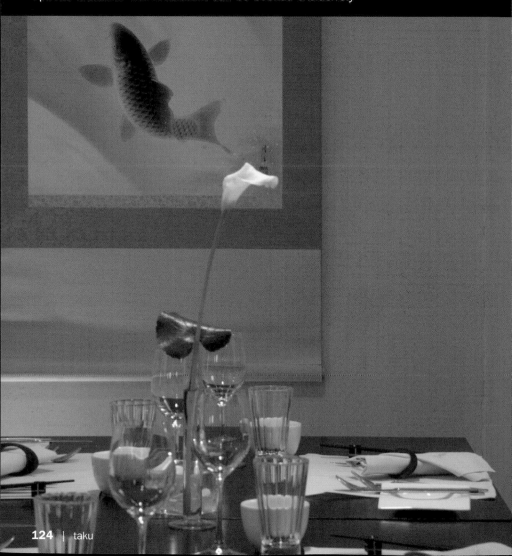

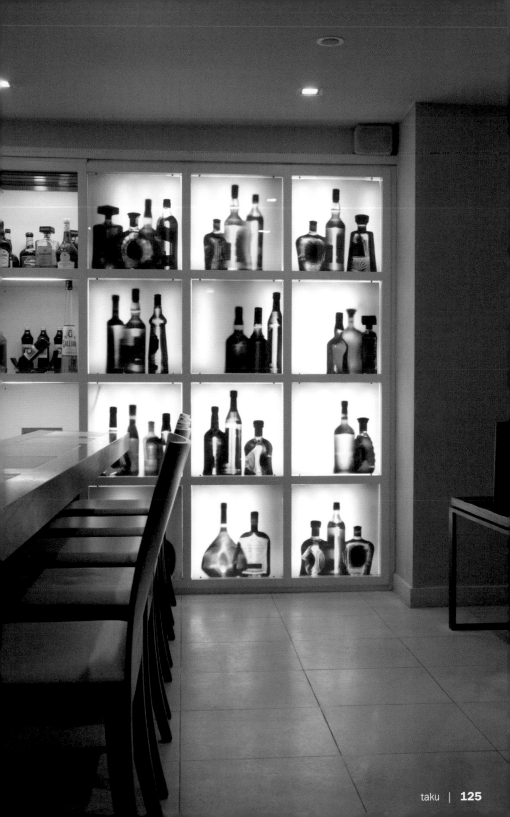

Entencurry

Duck Curry
Curry de canard
Pato al curry
Curry all'anatra

4 Entenbrüste, geputzt
Salz, Pfeffer
3 EL Erdnussöl

3 EL Matsaman-Currypaste
3 Limettenblätter
1 TL Kreuzkümmel, geröstet und zerstoßen
2 TL Koriandersamen, geröstet und zerstoßen
1 Prise Zimt
1 Prise Kardamom
1 rote Chili, in Streifen
500 ml Kokosmilch
500 ml Geflügelfond

80 g Bambussprossen
80 g Schlangenbohnen
60 g Baby-Mais
4 Stangen grüner Spargel

Salz, Pfeffer, Chilipaste, Fischsauce
1 Bund Thai-Basilikum, grob gehackt

Die Entenbrüste würzen und auf der Hautseite 2 Minuten in Erdnussöl kross braten, dann bei 180 °C 10 Minuten im Ofen garen. Die Currypaste mit den Limettenblättern anschwitzen, die Gewürze dazugeben und mit Kokosmilch und Geflügelfond ablöschen. 5 Minuten köcheln lassen, dann das Gemüse hinzufügen und mit Salz, Pfeffer, Chilipaste und Fischsauce abschmecken. Die Basilikumblätter unterrühren und mit den tranchierten Entenbrüsten servieren.

4 duck breasts, cleaned
Salt, pepper
3 tbsp peanut oil

3 tbsp Matsaman curry paste
3 lime leaves
1 tsp cumin, roasted and ground
2 tsp coriander seeds, roasted and ground
1 pinch cinnamon
1 pinch cardamom
1 red chili, in strips
500 ml coconut milk
500 ml chicken stock

3 oz bamboo shoots
3 oz runner beans
2 oz baby corn
4 spears green asparagus

Salt, pepper, chili paste, fish sauce
1 bunch Thai basil, roughly chopped

Season the duck breasts and fry in peanut oil for 2 minutes on the skin-side, until crispy. Then bake in the oven at 350 °F for 10 minutes. Sautée the curry paste with the lime leaves, add the spices and pour in the coconut milk and chicken stock. Allow to simmer for 5 minutes, then add the vegetables and season to taste with the salt, pepper, chili paste and fish sauce. Stir in the basil leaves and serve with the carved duck breasts.

4 magrets de canard nettoyés
Sel, poivre
3 c. à soupe d'huile d'arachide

3 c. à soupe de pâte de curry Matsaman
3 feuilles de citron vert
1 c. à café de cumin grillé et concassé
2 c. à café de graines de coriandre grillées et
concassées
1 pincée de cannelle
1 pincée de cardamome
1 piment rouge en lamelles
500 ml lait de coco
500 ml bouillon de volaille

80 g pousses de bambou
80 g de haricots ficelle
60 g de maïs baby
4 asperges vertes

Sel, poivre, pâte de piment rouge, sauce de poisson
1 bouquet de basilic thaï grossièrement haché

Aromatiser les magrets de canard et les saisir 2 minutes dans l'huile côté peau de sorte qu'ils soient croustillants, puis les faire cuire 10 minutes au four à 180 °C. Faire blondir la pâte de curry et les feuilles de citron vert, ajouter les épices et mouiller de lait de coco et de bouillon de volaille. Laisser mijoter 5 minutes, ajouter les légumes, saler, poivrer, puis incorporer la pâte de piment et la sauce de poisson. Ajouter les feuilles de basilic et servir avec les magrets coupés en tranches.

4 pechugas de pato, limpias
Sal, pimienta
3 cucharadas de aceite de cacahuete

3 cucharadas de pasta de curry Matsaman
3 hojas de lima
1 cucharadita de comino, tostado y molido
2 cucharaditas de semillas de cilantro, tostadas
y molidas
1 pizca de canela
1 pizca de cardamomo
1 guindilla roja, en juliana
500 ml de leche de coco
500 ml de fondo de volatería

80 g de brotes de bambú
80 g de judías serpiente
60 g de maíz baby
4 troncos de espárragos verdes

Sal, pimienta, pasta de guindilla, salsa de pescado
1 ramito de albahaca *thai*, ligeramente picada

Sazone las pechugas de pato y fríalas bien durante 2 minutos por el lado de la piel en aceite de cacahuete, estófelas después en el horno a 180 °C durante 10 minutos.Rehogue la pasta de curry con las hojas de lima, añada las especias y vierta dentro la leche de coco y el fondo de volatería. Deje que hierva a fuego lento durante 5 minutos, añada después la verdura y condimente con sal, pimienta, pasta de guindilla y salsa de pescado. Incorpore las hojas de albahaca y sirva con las pechugas de pato trinchadas.

4 petti d'anatra puliti
Sale, pepe
3 cucchiai di olio di arachidi

3 cucchiai di pasta di curry Matsaman
3 foglie di limetta
1 cucchiaino di cumino tostato e pestato
2 cucchiaini di semi di coriandolo, tostati e
pestati
1 presa di cannella
1 presa di cardamomo
1 peperoncino rosso a striscioline
500 ml di latte di cocco
500 ml di brodo di pollo

80 g di germogli di bambù
80 g di fagiolini rampicanti
60 g di mini-pannocchiette di mais
4 mazzi di asparagi verdi

Sale, pepe, pasta di peperoncino, sugo di pesce
1 mazzetto di basilico tailandese triturato grossolanamente

Condire i petti d'anatra e rosolarli per 2 minuti nell'olio di arachidi dalla parte della pelle, quindi farli cuocere in forno a 180 °C per 10 minuti. Soffriggere la pasta di curry con le foglie di limetta, unire gli aromi e bagnare con il latte di cocco ed il brodo di pollo. Cuocere a fiamma bassa per 5 minuti, quindi aggiungere le verdure, salare, pepare e condire con la pasta di peperoncino ed il sugo di pesce. Unire le foglie di basilico, tranciare i petti d'anatra e servire.

d ^ blju 'W'

Design: Klemens Hüls | Chef: Christoph Richartz
Owner: Hotel im Wasserturm

Kaygasse 2 | 50676 Köln | Stadtmitte
Phone: +49 221 2 00 81 83
www.hotel-im-wasserturm.de
Subway: Poststraße
Opening hours: Mon–Fri noon to 2:30 pm, 6 pm to 11 pm
Average price: € 20
Cuisine: International-Seasonal
Special features: Famous for being located in Europe's oldest water tower

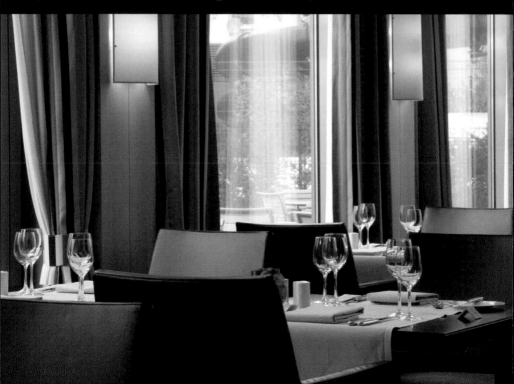

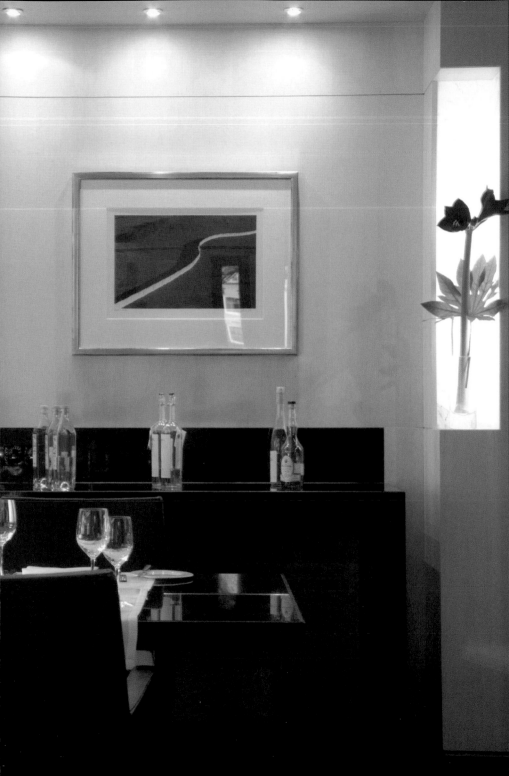

Gegrillte Dorade
mit Oliven-Limetten-Marinade

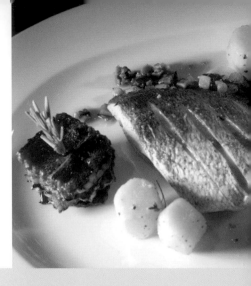

Grilled Sea Bream with Olive-Lime
Marinade

Dorade grillée avec marinade d'olive et
de citron vert

Dorada asada con marinada de aceitunas
y limas

Orata alla griglia con marinata di olive
e limette

4 Doraden, à 180 g
2 EL Olivenöl
Salz, Pfeffer
Fenchelkraut von 2 Fenchelknollen
4 Zweige Thymian

100 ml Geflügelfond
3 EL Olivenöl
1 EL Limettensaft
10 schwarze Oliven, gewürfelt
10 grüne Oliven, gewürfelt
3 EL Olivenöl
1 Zucchini, gewürfelt
1 Aubergine, gewürfelt
1 rote Paprika, gewürfelt
Salz, Pfeffer
2 Zweige Rosmarin
24 kleine Kartoffeln, gekocht und geschält

Die Doraden einschneiden, mit Olivenöl einpin-
seln, würzen und auf ein mit Backpapier belegtes
Backblech geben. Fenchelkraut und Thymian
auf dem Fisch verteilen und bei 180 °C ca. 15
Minuten im Ofen garen.

Für die Marinade den Geflügelfond mit Olivenöl,
Limettensaft und Oliven mischen und abschme-
cken. Die Gemüsewürfel in Öl anschwitzen, mit
Rosmarin, Salz und Pfeffer würzen und warm
stellen.

Jede Dorade auf etwas Gemüseragout anrichten,
mit der Marinade garnieren und mit Kartoffeln
servieren.

4 sea bream, à 6 oz
2 tbsp olive oil
Salt, pepper
Fennel leaves of 2 fennel roots
4 sprigs thyme

100 ml chicken stock
3 tbsp olive oil
1 tbsp lime juice
10 black olives, diced
10 green olives, diced
3 tbsp olive oil
1 zucchini, diced
1 eggplant, diced
1 red pepper, diced
Salt, pepper
2 sprigs rosemary
24 small potatoes, cooked and peeled

Score the sea breams, coat with olive oil, season
and place on a baking tray covered with baking
paper. Scatter the fennel and thyme over the fish
and bake in the oven for approx. 15 minutes at
350 °F.

For the marinade, mix the chicken stock with
the olive oil, lime juice and olives and season to
taste. Sautée the diced vegetables in oil, season
with rosemary, salt and pepper and keep warm.

Arrange each sea bream on the vegetable ragout,
garnish with the marinade and serve with pota-
toes.

4 dorades dc 180 g
2 c. à soupe d'huile d'olive
Sel, poivre
Feuilles de fenouil provenant de 2 bulbes
4 branches de thym

100 ml bouillon de volaille
3 c. à soupe d'huile d'olive
1 c. à soupe de jus de citron vert
10 olives noires coupées en dés
10 olives vertes coupées en dés
3 c. à soupe d'huile d'olive
1 courgette coupée en dés
1 aubergine coupée en dés
1 poivron rouge coupé en dés
Sel, poivre
2 branches de romarin
24 petites pommes de terre cuites et épluchées

Inciser les dorades, les badigeonner d'huile d'olive, les épicer et les enfourner sur une plaque couverte de papier d'aluminium. Répartir le fenouil et le thym sur le poisson et cuire à 180 °C pendant 15 minutes environ.

Pour la marinade, mélanger le bouillon de volaille, l'huile d'olive, le jus de citron vert et les olives, puis assaisonner. Faire revenir les légumes, ajouter le romarin, le sel et le poivre et garder au chaud.

Disposer chaque dorade sur du ragoût de légume, garnir avec la marinade et servir avec les pommes de terre.

4 doradas, de 180 g cada una
2 cucharadas de aceite de oliva
Sal, pimienta
Las hojas de dos bulbos de hinojo
4 ramitas de tomillo

100 ml de fondo de volatería
3 cucharadas de aceite de oliva
1 cucharada de zumo de lima
10 aceitunas negras, en dados
10 aceitunas verdes, en dados
3 cucharadas de aceite de oliva
1 calabacín, en dados
1 berenjena, en dados
1 pimiento rojo, en dados
Sal, pimienta
2 ramitas de romero
24 patatas pequeñas, cocidas y peladas

Haga cortes en las doradas, píntelas con aceite de oliva, condimente y colóquelas sobre una bandeja de horno forrada con papel vegetal. Reparta las hojas de hinojo y el tomillo por encima del pescado y áselo en el horno durante aprox. 15 minutos a 180 °C.

Para preparar la marinada mezcle el fondo de volatería con el aceite de oliva, el zumo de lima y las aceitunas y condimente. Rehogue los dados de verdura en el aceite, condimente con el romero, la sal y la pimienta y reserve caliente.

Ponga cada dorada encima de un poco de verdura, decore con la marinada y sirva con patatas.

4 orate di 180 g ciascuna
2 cucchiai di olio d'oliva
Sale, pepe
2 fronde di finocchio
4 ramoscelli di timo

100 ml di brodo di pollo
3 cucchiai di olio d'oliva
1 cucchiaio di succo di limetta
10 olive nere tagliate a dadini
10 olive verdi tagliate a dadini
3 cucchiai di olio d'oliva
1 zucchino tagliato a dadini
1 melanzana tagliata a dadini
1 peperone rosso tagliato a dadini
Sale, pepe
2 ramoscelli di rosmarino
24 patate piccole bollite e spellate

Praticare dei tagli sulle orate, spennellarle con l'olio d'oliva, condirle e porle su una leccarda coperta di carta da forno. Cospargere il pesce con il finocchio ed il timo e farlo cuocere in forno a 180 °C per circa 15 minuti.

Preparare la marinata mescolando il brodo di pollo con l'olio d' oliva, il succo di limetta e le olive, assaggiare e regolare il condimento. Soffriggere nell'olio la verdura a dadini, aggiungere il rosmarino, salare, pepare e tenere in caldo.

Disporre ogni orata su un poco di ragù di verdure, guarnire con la marinata e servire con le patate.

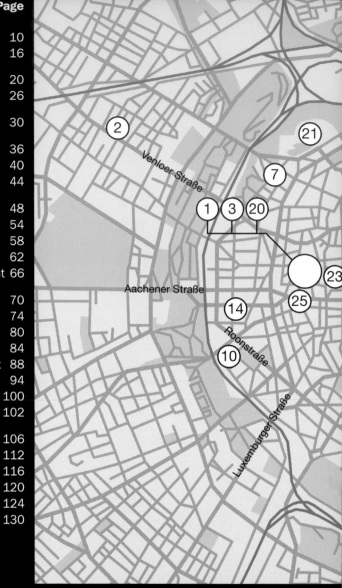

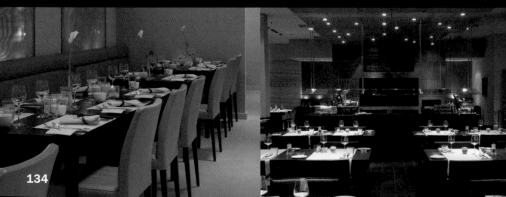

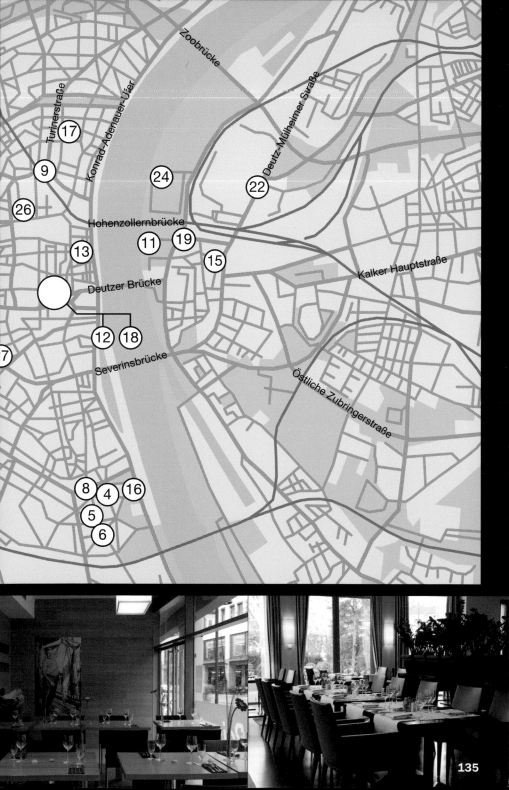

Cool Restaurants

Size: 14 x 21.5 cm / 5 $\frac{1}{2}$ x 8 $\frac{1}{2}$ in.
136 pp, Flexicover
c. 130 color photographs
Text in English, German, French,
Spanish, Italian or (*) Dutch

Other titles in the same series:

Amsterdam
ISBN 3-8238-4588-8

Mallorca/Ibiza
ISBN 3-8327-9113-2

Barcelona
ISBN 3-8238-4586-1

Miami
ISBN 3-8327-9066-7

Berlin
ISBN 3-8238-4585-3

Milan
ISBN 3-8238-4587-X

Brussels (*)
ISBN 3-8327-9065-9

Munich
ISBN 3-8327-9019-5

Cape Town
ISBN 3-8327-9103-5

New York 2nd edition
ISBN 3-8327-9130-2

Chicago
ISBN 3-8327-9018-7

Paris 2nd edition
ISBN 3-8327-9129-9

Côte d'Azur
ISBN 3-8327-9040-3

Prague
ISBN 3-8327-9068-3

Frankfurt
ISBN 3-8237-9118-3

Rome
ISBN 3-8327-9028-4

Hamburg
ISBN 3-8238-4599-3

San Francisco
ISBN 3-8327-9067-5

Hong Kong
ISBN 3-8327-9111-6

Shanghai
ISBN 3-8327-9050-0

Istanbul
ISBN 3-8327-9115-9

Sydney
ISBN 3-8327-9027-6

Las Vegas
ISBN 3-8327-9116-7

Tokyo
ISBN 3-8238-4590-X

London 2nd edition
ISBN 3-8327-9131-0

Toscana
ISBN 3-8327-9102-7

Los Angeles
ISBN 3-8238-4589-6

Vienna
ISBN 3-8327-9020-9

Madrid
ISBN 3-8327-9029-2

Zurich
ISBN 3-8327-9069-1

To be published in the
same series:

Dubai
Copenhagen
Geneva

Moscow
Singapore
Stockholm